Knots Landing

TV Milestones

Series Editors
Barry Keith Grant
Brock University

Jeannette Sloniowski
Brock University

TV Milestones is part of the Contemporary Approaches to Film and Media Series.

A complete listing of the books in this series can be found online at wsupress.wayne.edu

General Editor
Barry Keith Grant
Brock University

KNOTS LANDING

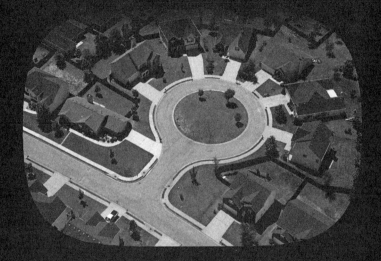

Nick Salvato

TV MILESTONES SERIES

Wayne State University Press Detroit

19 18 17 16 15 5 4 3 2 1

ISBN 978–0-8143-4033-2 (paperback: alk. paper); ISBN 978–0-8143-4034-9 (ebook)

Library of Congress Control Number: 2014954157

CONTENTS

v

ACKNOWLEDGMENTS

I owe debts of gratitude to the many individuals and institutions that helped make the process of writing this book not only possible but also pleasurable. The project benefited from the collegiality and friendship of a number of interlocutors, including Brian Herrera, who read and commented sharply on an early draft of the book proposal (and who more recently pointed me toward a delicious reference to *Knots Landing* in *General Hospital*, one of whose characters describes watching *Knots* as "the gay gateway from casual to carnal"!); Mimi White, who provided helpful references and insights during my initial phase of research; and Carlynn Houghton, who joined me for "Ithaca Writers' Camp" in July 2013 and spurred the generation of a number of ideas. In sometimes similarly explicit—yet at other times in valuably indirect—fashion, other dear folks engaged me in conversations about television and thus informed this book, less and (happily) more strangely. A list of them, for whose partiality I apologize, must name Amy Villarejo, Andrea Hammer, Hollis Griffin, Aoise Stratford, Jacob Brogan, Clare Hane, Jeremy Handrup, Lucas Hilderbrand, Alan Ackerman, Sabine Haenni, Sara Warner, Patricia Keller, Anna Watkins Fisher, Lynne Joyrich, Phillip Maciak, Tristan Snell, Jane Carr,

Masha Raskolnikov, and Jennifer Tennant. Amy, every word about hair is for you.

Some acknowledgments must extend backward to the 1980s themselves, when *Knots Landing* first aired on CBS. With an eye trained on that era, I thank my mother, Annette Salvato, for letting me stay up late to watch *Knots* in my youth; my father, Nicholas Salvato, for having the decency and good sense to watch *L.A. Law* in some other room of the house and thus ceding the living room to *Knots* on Thursday nights; and my grandmother, Lee Drappi, for the yet prior introduction to daytime serials, which enabled me to understand with intimacy those serials' relationship to primetime.

Family is one kind of structure. Television and its archivists and curators form another. I would never have been able to undertake the present work without a little help from TNT, which aired reruns of *Knots Landing* in the early 1990s; the founders and maintainers of the website www.knotslanding.net, an astonishing trove of materials including interviews with *Knots* personnel; and the staff at the Paley Center for Media in New York City, who provided cheerful assistance and encouragement as I worked with items in their collection.

At Wayne State University Press, senior acquisitions editor Annie Martin has been a more generous and thoughtful collaborator than I could have hoped to find in undertaking and seeing to completion my work on this book. Likewise, TV Milestones series editors Jeannette Sloniowski and Barry Keith Grant have offered indispensable input at various stages in the writing and production process, and the book would never have risen to whatever level of quality it achieves without detailed, trenchant feedback from the press's anonymous peer reviewers, to whom I am grateful for the care of their reports. Alicia Vonderharr is a similarly careful and scrupulous copyeditor. Any persisting errors, lacks, or deficits are solely mine to acknowledge.

Most important, I dedicate this book to Samuel Buggeln, who makes me feel something like I'm seeing the ocean for

the first time every day that we spend together, and to Maria Fackler, who has never failed to grab her handbag to join me on an investigation. Maria also watched an avalanche of *Knots Landing* with me, courtesy of SOAPNet, as part of our shared, desperate response to the siren call of "Afternoon Delights" that the network's syndication schedule and advertising campaign promised in the early 2000s. These were years in which we were graduate students left essentially alone with our work for long spells, and we often wrestled in those spells to understand how to mark and socialize the passing of time. With television, we figured some of it out. The epic and warm conversations we had then, alongside the ones since (both about other things when they were ostensibly about *Knots Landing* and, more surprising and revealing, about *Knots Landing* when they were ostensibly about other things) form such a strong, rich part of my life that I scarcely know where, or who, I would be without them. (*Swallow*) I give my sometime neighbor and lifelong best friend, which is to say my kin, profound thanks and love.

Introduction

The Little Engine That Did

❙❙ Coming up—a new beginning in *Knots Landing*. New neighbors, [. . .] new families with new problems, new doubts, getting involved again: for Val and Gary Ewing, finding new hope. Welcome to their new home. And now . . ." With these words spoken in voiceover, the teaser for the December 27, 1979, pilot of primetime series *Knots Landing* (CBS, 1979–93) gives way to its opening credit sequence. This sequence reinforces the scenario that the teaser establishes, working to develop relationships among character, place, and situation. A circling aerial shot of the Pacific Ocean and southern California coastline dissolves into a bird's-eye view of another circle: Seaview Circle, the cul-de-sac in Los Angeles suburb Knots Landing where Val (Joan Van Ark) and Gary Ewing (Ted Shackelford) will make the "new beginning" and meet the six "new neighbors" described in the teaser. Val and Gary's "new hope" is the one that they embrace as star-crossed lovers torn apart earlier and now reunited, and their "new home" takes them

far from *Dallas* (CBS, 1978–91), the hit series where they were previously seen as guest characters. Verbalized in the teaser, this information is reintroduced ingeniously in the credit sequence's images. First we see the cul-de-sac's four pairs of couples in clips pulled from forthcoming episodes of the series. Movement-filled, the clips are superimposed as four "slices" on the otherwise static shot of the couples' four respective tract houses. Then, the eight actors reappear one by one in a similar superimposition of their faces onto the image of tract housing. Between each of these twelve shots, the camera moves, strongly and repetitively, back to the paved road at the center of the cul-de-sac. These movements emphasize that the road is shaped, from an aerial perspective, like a keyhole. In this way, the cul-de-sac is figured as a site where viewers will spy—as if through

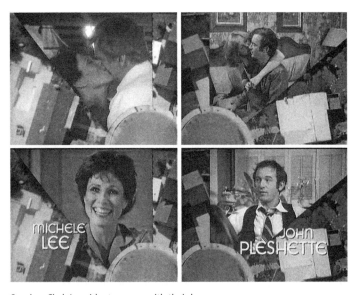

Seaview Circle's residents merge with their houses.

PjQf

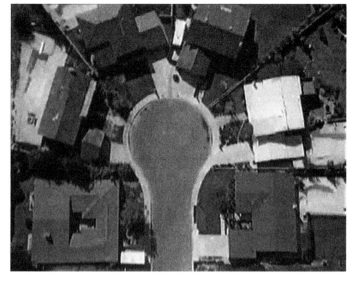

The cul-de-sac is a kind of keyhole into which we spy or slip.

such a keyhole—the lives secreted in its houses. The houses are thus made dynamically worth acquaintance: their denizens, it is suggested, will embody the alluring tension of "new problems" and "new doubts" with the stirring ambition of "new hope." Moreover, the keyhole evocation blurs the distinction between the communal (a street) and the private (a door). Similarly, the very regular, rhythmic movement from a shot of one featured player to another levels the differences among the eight of them. Taken together, these devices begin the work that will be performed more elaborately by the series itself. Like other cultural products concerned with American, middle-class domesticity, *Knots Landing* explores the tricky resemblance of one thing, one person, one house to another. The series also discloses the pleasurable difficulty in "tell[ing] the difference between inside and outside—between what's inside [the] body and what's out

there, between what's inside the house and what's outside in the neighborhood or on the other side of town, between [in-dividual] heartbreak and the misery in the world beyond [the self]" (Cvetkovich 158).

In the pilot, the problems "outside in the neighborhood" seem grievous enough that Val ventures to Gary, "I don't think we should live here." But as it traces an arc from this moment to the end of the first season, the series finds such problems just as prominently at play "inside the house" where Gary and Val live. That season wraps with a two-part episode in which alcoholic Gary falls off the wagon and engages in a days-long, drunken tear through Los Angeles that threatens his marriage. In the first installment of this two-part season finale, "Bottom of the Bottle (1)" (episode twelve in season one), neighbor and confidante Karen Fairgate (Michele Lee) convinces Val not to give up on marriage to Gary. To boost her spirits, Karen hails Val as "The Little Engine That Could":

> KAREN: I don't think it's over, and neither do you.
>
> VAL: Well, I don't want to, but, I don't know, there's a time to give up, and maybe this is it.
>
> KAREN: Maybe it is. Or maybe it isn't. [. . .] Why should it all be smooth sailing? [. . .]
>
> VAL: If you want to know the truth, sometimes I don't think I've got it in me.
>
> KAREN: Oh, stop it, of course you do. I've seen you. You're made of granite rock. "I don't think I have it in me." Come on. [*Beat.*] You know, we joke about you behind your back. We call you The Little Engine That Could—and you can. You do everything you can to make this your home: to protect your home, and your husband.

VAL: All I know is, when I think about life without Gary [. . .], I just come all apart.

KAREN: I guess you have no choice then.

Thirteen years later, during a key installment of the final season of the long-running series, "Love and Death" (episode five in season fourteen), Karen once again calls Val "The Little Engine That Could." This time she does so as part of a eulogy delivered at Val's funeral, following her (presumed) death in a fiery car accident:

The Little Engine That Could: Valene. I never met anyone named Valene before I met Val. I never met anyone *like* Valene before I met her. She talked funny. She wore her hair funny. She dressed with a remarkable [*beat*] let's call it originality. She was a country girl with a special way of looking at things that was her own. Simple. Seemingly simple, anyway. So simple and so vulnerable that she made me feel protective. She made me feel like taking her under my wing and keeping her there, safe. What a conceit. How could I think I could protect her? She had come through so much. She was tougher than most people I know. Valene: tough enough to be The Little Engine That Could. She absolutely could not be stopped. I started out feeling protective, and I ended up looking to Valene for examples: examples of loyalty and kindness and tough determination and, above all, love. She was my best friend.

Separated by the gulf of years, these moments may be understood, on one level, as accomplishing vastly different goals. The first moment emphasizes the "home" and "husband" worth "protect[ing]." In this way, it affirms the norm of monogamous fidelity, a guiding value for series and serials like *Knots Landing* (even as such programs must trouble marital stasis to motor

their ongoing narratives). A feature of middle-class respectability, this norm finds its material complements in a carefully appointed print of a horse on a wall, a lamp decorously situated on an end table: items that we see over Val and Karen's shoulders in the shots and reverse shots that constitute the scene. Meanwhile, the second moment, Karen's narrative retrospection about the life of her friend, also nods to the series' own history. With this nod, the scene aims to stir a feeling of gauzy nostalgia, visually reinforced by the lush, pink flowers that frame and soften black-clad, commanding Karen at a church lectern. That nostalgia comes as a reward to the longtime, dedicated viewers of the series, who will remember the earlier, tonally different "engine" scene.

Yet, on another level, the two moments could be understood as doing similar, indeed intimately related, kinds of work. Each scene contains an allegory, a narrative with both literal and non-literal meanings, and both allegories center on Val, an at-first tentative, ultimately successful writer of melodramatic fictions much like *Knots Landing*'s own. Through the allegory, Val stands for the series itself: an initial "underdog" effort that became one of the most popular American television series of the 1980s. Just like Val's marriage to Gary, *Knots Landing*, at the end of its first season, is a series not to "think" of as "over." Rather, as Karen's dialogue slyly suggests, CBS should "have no choice" but to renew the series because it can, as a stealthily tough-as-"granite" Little Engine, proceed to "do everything" that a series ought to do. And as it is renewed not just for that second season but also for twelve more, the series becomes akin, again, to Val. By the time of "Love and Death," *Knots Landing* itself is readable as an effort that "absolutely could not be stopped," stuffed in that unstoppability with "examples of loyalty and kindness and [. . .] determination and [. . .] love."

In other words, "Love and Death" eulogizes not just Val but *Knots Landing*, too. And in so doing, it confers recognition on the series' achievement of longevity: the milestone that it

has become. This episode aired at a pivotal moment in American television history, when CBS and the other major networks weathered what Amanda Lotz calls television's "multi-channel transition" (7). As part of the transition, the networks developed new programming strategies and moved away from expensive-to-produce fare like *Knots Landing*. In Jane Feuer's words, these changes are features of a "twilight period"; they mark "the end of the era of American network television as we had known it from the 1950s" (3) because of the explosion of "many more available channels to choose from than ever before" (Edgerton 9). Responsive and contributing to this sense of "twilight," the makers of *Knots Landing* generated self-memorializing episodes, like "Love and Death," for the series' fourteenth season. They did so with the knowledge that this season would also, on the judgment call of series creator and co-executive producer David Jacobs, be its last. Jacobs made this judgment in order to end the series by design and with careful creative calibration, rather than face a later, perhaps unpredictably timed cancellation by CBS. Thus his decision speaks not only to aesthetic considerations but also to the increasing economic unsustainability of "big '80s" television in the early 1990s. In her retrospective account of the series' conclusion, Deborah Wilker addresses this very impact of economics on aesthetics:

> Standard '80s production costs were suddenly too high in the '90s. And most of the cast had been on [*Knots Landing*] so long, their annual raises alone broke the bank. Corners were cut, and though the quality dipped only slightly, the show's creator, David Jacobs, couldn't bear it. In 1992 talks began with CBS about ending it by mutual agreement. The next year some cast members took concessions to keep *Knots* alive one last season—unheard of in Hollywood, but that's how much these people liked their work. (1E)

7

Among the "concessions" to which Wilker alludes, most notable perhaps was Michele Lee's deal to work on certain fourteenth-season episodes at "scale pay" so that her character could appear in all 344 installments of the series. Lee, a self-described fan of *Knots Landing* as well as one of its luminaries, was determined to achieve this milestone record through whatever ingenious, unorthodox maneuvers the task necessitated (Lee 2003). As "Love and Death" testifies, Karen "ended up looking to Valene," "The Little Engine That Could," as an ethical model. In turn, as we see in her willingness to work for less money, Lee ended up looking *like* a version of that ethical Little Engine, as did the series on the whole.

In short, *Knots Landing* retained and evolved a persistent association with "The Little Engine That Could" throughout its impressively long run. This remained the case even after the series had cemented its popularity with millions of viewers first in the American market and then worldwide. And it is perhaps this ongoing "underdog" image that makes the series a somewhat neglected milestone. (The engine association still sticks. *Knots Landing* was recently hailed as groundbreaking in the series *Pioneers of Television* [PBS, 2008–]. Yet, in a concurrent interview for *The Talk* [CBS, 2010–], Lee described the series, now explicitly rather than implicitly, as "The Little Engine That Could.") But in the end, *Knots Landing* was less "The Little Engine That Could" than the little engine that *did*—just like the victorious train in the children's story. As such, it deserves its further attribution as a "TV Milestone." Since a milestone is a marker of significance, success, or exceptionality, let's start by setting up four such markers that will orient us as we proceed to explore *Knots Landing*'s milestone status in greater depth. (1) *Knots Landing* was *Dallas*'s spinoff: a series that took concepts and characters from the previous popular hit and relocated them to another place. Yet *Knots Landing* outlasted its predecessor to become the third longest-running primetime dramatic series in American television (after *Gunsmoke* [CBS, 1955–75]

and *Law & Order* [NBC, 1990–2010]). (2) Unlike the other primetime dramatic hits of its period, *Knots Landing* distinguished itself by exploring middle-class lives and values. In this way, it anticipated and directly influenced such later, important series as *Desperate Housewives* (ABC, 2004–12) and *Six Feet Under* (HBO, 2001–5). (3) A huge commercial success, *Knots Landing* routinely outperformed the more critically lauded series with which it competed in the programming lineups (*Hill Street Blues* [NBC, 1981–87], *L.A. Law* [NBC, 1986–94]). Among other factors, this outperformance invites us to wonder what different appeals *Knots Landing* made to viewers who chose to watch it instead of series like *Hill Street Blues*. (4) *Knots Landing* made icons out of its principal players and launched the careers of later luminaries like Alec Baldwin. Unusually capable of star-making, the series also gave pivotal second (or third) acts to fine Hollywood actors of the classic studio era, including Ava Gardner and Julie Harris.

In the four chapters that follow, I explore in further detail the achievement that each of these markers indicates. To begin, chapter 1 examines *Knots Landing*'s status as a spinoff of *Dallas* that runs longer than *Dallas* does. Yet it is not just the long run of *Knots Landing* that warrants its designation as a special series. More important, *Knots Landing* developed a distinctive, impressive set of strategies in order to remain widely popular and commercially viable for fourteen years. Its duration is simply a measurable milestone, but its successful *endurance*—not a matter of luck but of skill and care—is a much more complex milestone. As chapter 1 charts, the "secret" to this enduring success has a number of different elements, which include the following: (1) *Knots Landing* told fictional stories that were essentially (if trickily) faithful to reality. Though ongoing and complicated, those stories remained likewise faithful to the series' own history and thus faithful, too, to viewers' memories of that history. In these ways, *Knots Landing* treated its viewers with dignity and respect, and the viewers rewarded the series

9

by tuning in steadily and loyally. (2) In an even more direct way, *Knots Landing*'s producers listened to viewers' criticisms and responded to those criticisms as they shaped the series' stories. The producers also gave the series' stars an unprecedented level of input in the writing process, and the resulting narratives and characterizations were much stronger and more interesting than they otherwise would have been. (3) In the rare, more extreme cases of having disappointed viewers or featured players (or both), the producers took unusual care to "right" the series and retool it before it ever went too awry. (4) Those retooling efforts were just one small aspect of *Knots Landing*'s larger, careful stewardship of its seriality: its telling of open-ended stories in episodes that demand to be watched regularly and in order. By growing and changing its forms of seriality in well-planned, well-timed ways, *Knots Landing* generated a great deal of pleasure for its audiences. (5) Perhaps its most poignant achievement, *Knots Landing* used these serialized stories to value the lived, social experience of time. Yet *Knots Landing* did more than reflect the viewers' experience of time in the experiences of its characters. The series also developed highly distinctive, formal attributes to signal that it was "keeping time" in a knowing and responsible way.

In one very exceptional moment, *Knots Landing* had to make a tough call in order to "keep time" responsibly. As a spinoff of *Dallas*, *Knots Landing* occasionally featured episodes in which characters from *Dallas* appeared. (*Dallas* would sometimes do the same.) Yet about halfway through the runs of both series, *Dallas* started telling its stories in such a way that to remain in conversation with *Dallas* would have threatened the integrity of *Knots Landing*. In an unprecedented move, *Knots Landing*'s producers had the bravery to end their relationship with *Dallas* and cease crossover episodes that tied the two series together. This move proved wise and enabled *Knots Landing* to retain an appreciative, core audience. Moreover, this move was more possible than it might be for other spinoffs more fully indebted

to their predecessor series. As we shall see in more detail, *Knots Landing* is exceptional among spinoffs because it was imagined *before Dallas*, though produced later. For this reason (among others), it always had a unique potential to move in its own, singular direction. Yet at the same time, *Knots Landing*'s status as an exceptional spinoff is precisely what situates the series to teach us important lessons about the spinoff genre as such.

In turn, chapter 2 explores how *Knots Landing* is unique and exceptional not among spinoffs but among the other serial, primetime dramas of its period. Where those other programs, like *Dallas*, featured super-rich characters, *Knots Landing* told stories about the middle class: a milestone, since extremely few American dramas (rather than sitcoms) had previously taken up this mantle in primetime. The decision to tell these middle-class stories had a number of consequences that further distinguished *Knots Landing* from other, dominant television fare: (1) the series could establish a different orientation toward romantic love and toward the relationship of romantic love to marriage; (2) it could offer an important alternative perspective on corporate business; and (3) it could develop a unique interplay of the ordinary and the extraordinary. At the same time, it would be misleading to suggest that *Knots Landing only* focused on middle-class stories, though such stories were always at the center of the series. *Knots Landing* also chronicled the lives of characters introduced as wealthy or who became wealthy—as well as characters who lost big money or, less dramatically, slid from middle-class comfort into poverty. Yet with complexity and distinction, *Knots Landing* told these "non"-middle-class stories in nonetheless eminently middle-class ways. In other words, *Knots Landing*'s relationship to "middle-classness" was multivalent: the series could locate middle-class feeling in a number of diverse spaces and registers. With such dimensionality, the series could also use middle-class feeling to take the temperature of American politics and a majority of the public's responses to these politics. And *Knots Landing* had this special

capacity—again, one that differentiated it from other primetime hits in the 1980s—because the American politics in question were themselves fixed on middle-class appeals, concerns, and voters. In part, *Knots Landing* sustained its attractiveness to many viewers because, like the most successful politicians in its period, the series directly addressed those viewer-citizens as a middle class with changing fortunes. Since that time, American politics have *remained* fixed on hailing middle-class constituencies. For this reason, *Knots Landing* became a crucial model for later series (many of them, such as *Breaking Bad* [AMC, 2008–13], milestones in their own right) that wished, like *Knots Landing*, to be responsive to national conceptions of the middle class and its ups and downs.

Knots Landing also anticipated important later primetime series through the special way in which it brought a *gendered* version of seriality to the primetime series form. Series including *Hill Street Blues*, alongside *Knots Landing*, likewise helped to develop the episodic series/continuous serial hybrid for American primetime television, but the former communicated this hybrid energy largely in masculine appeals and addresses. By contrast, *Knots Landing*, overtly closer to the daytime serials that preceded it, made more feminine appeals and was thus "feminized" in popular responses to the series. And because *Knots Landing* never concealed its debt to these derided daytime serials, or "soap operas," it also couldn't claim an uncomplicated relationship (as, say, *Hill Street* could) to the idea of television "quality." Indeed, that relationship to "quality" is further complicated by *Knots*'s interesting debt, related to its traffic with soap opera, to *cinematic* precedents that were both "quality" and non-"quality," "art" and "trash." Thinking about *Knots Landing*'s place in a larger media history, which includes different kinds of films, situates us in a valuable position. It enables us to put special, critical pressure on such terms as "art" and "trash," which can distract us from clearly assessing the important, indeed potentially milestone features of various cultural artifacts.

In fact, one milestone feature of *Knots Landing* lies precisely in its exciting use of "quality" elements, despite its past categorization as a non-"quality" or "trashy" program. As we shall see in close analyses of "special event" episodes, *Knots Landing*'s "quality" elements, often tied to its gendered appeals, manifest in the following ways: (1) in the subtle texturing and re-texturing of relationships among characters; (2) in sophisticated audiovisual work; and (3) in the resulting ability to raise smart, philosophical questions about television as a medium. Perhaps even more impressive, *Knots Landing* doesn't just "wait" for special event episodes (like its milestone 200th or 300th) to showcase its quality dimensions; some of these dimensions emerge even in more routine installments of the series. Thus to study *Knots Landing* calls productively into question what we mean when claiming that something is "quality" or not—and how ideas about gender shape powerfully who makes the claims, in what manner, and why.

All the same, *Knots Landing* doesn't shy away from a special, exuberant embrace of television elements that some commentators would call "trashy"—or at least trivial. These elements include (big) hair, (heavy) makeup, and (sugary pop) music. In some ways, this book's most daring argument is to insist, as *Knots Landing* did, on the importance of these aspects of television production. Indeed, *Knots Landing* is a milestone for taking "trivial" things like actors' eyes and hair and making unusual *stars* out of these things—not just stars of the actors themselves. As chapter 4 explains, *Knots Landing*'s special use of "starry" things is just as complex and intriguing as its use of "quality" elements. If the series' quality enables it to tell us savvy, philosophical things about television, so do its—well, *things*. In other words: ironic as it may seem at first blush (pardon the pun), makeup and hair are made for philosophy, and part of *Knots Landing*'s exceptional smartness is to show us how.

At the same time, *Knots Landing* also shows us the virtuosic performances of American acting legends, who get

career-reviving boosts from the series, and of soon-to-be legends, who get their first breaks in the series. The subtlety and beauty of these arresting star performances are landmarks in the history of television acting. Yet I am likewise arrested by an even subtler *Knots Landing* phenomenon. Far from showing us dazzling eye shadow in one scene and bravura performance in another, music "videos" before one commercial break and stirring acting after the next, *Knots Landing* dexterously *integrates* these diverse aspects of production. That complex feat is just as much a milestone—maybe more of one—than a star turn, like Julie Harris's in the series, that gets nominated for an Emmy award.

Like television itself, which produces many effects at different scales, the four chapters of this book also work at a variety of scales in order to demonstrate the different methods that we require to understand television series like *Knots Landing*: in the "big picture" contexts of industrial and political histories, at the fine-grained level of individual episode analyses, and on a number of registers in between. Then, in a short conclusion, I document how and why *Knots Landing* continues to matter. The series is a television precedent in both expected and unexpected ways, including as a model for dominant, "lifestyle" programming of today—sometimes called "property TV" (McElroy 44). This reality programming is relentlessly fixated on houses, homes, and how houses become homes, a fixation indebted to *Knots Landing*'s prior fascination with these very issues. Yet at the same time, the newer television arguably misses something special about home dwelling, particularly its place in community building, that *Knots Landing* does track. In turn, as I track that special quality of *Knots Landing*, I also trace a circle back to this Introduction. Here, we have already encountered *Knots Landing*'s own circling over the cul-de-sac and its houses, as rendered in the 1979 entrée to the series. That original credit sequence was filmed at Crystalaire Place in Los Angeles suburb Granada Hills, the site of continued, crucial location shooting

over the course of *Knots Landing*'s long run. By way of the dissolve described earlier, the credit sequence's establishing shot of the cul-de-sac suggests the proximity of that cul-de-sac to the ocean. And this association is driven home, as it were, when we learn that the (fictional) name of the cul-de-sac is *Seaview Circle*. Yet this work in image and language constitutes a bit of television trickery. Crystalaire Place is far from the ocean—and, in another sense, that shooting location was chosen for reasons "far from" the *geographic* coordinates of the site. David Jacobs explains the choice in a telephone interview with longtime fans of *Knots Landing*:

> What we wanted—because [Crystalaire Place] was [. . .] actually quite far from the beach—is [. . .] something on a hill, so that [. . .] we could film a car going down the hill, and then go to Redondo Beach, which was miles away and, you know, have them turn in as if [the car] had just come down that hill, and then, in one shot, take it to the beach to make it seem that we were right by the sea. (Quoted in Jacobs 2006)

15

Recall *Knots Landing*'s special blurring of inside and outside, private and public, self and neighbor, which I sketched at the top of this Introduction. The blurring of hillside and seaside works in concert with these other effects. More important, continued thinking about such blurring will itself be blended with the other topics of the chapters to follow. I make that move because the blurring in question is yet one more key milestone of *Knots Landing*. In a special and striking way, the series reveals how one thing transforms into another, yet stays itself, again and again, and back again. And in that way, the series' movements and rhythms are like the tidal lapping of the ocean. This oceanic quality of *Knots Landing* is more precious than its fabricated seaside location.

Of course, the fictional location of Seaview Circle near a "beach [. . .] right by the sea" is also important at the level of *Knots Landing*'s content. For instance, in the series' pilot, Val, who has "never seen the ocean," gets her first inspired glimpse of it and runs spontaneously through the surf. And such "splashy" running becomes a ritual that the character will repeat and cultivate in iconic scenes, over many years.

At its most interesting, *Knots Landing* sometimes collides the representation of the ocean at the level of content and "oceanic" movement at the level of form. Consider "The Longest Night," the seventh-season finale of *Knots Landing,* which marks the halfway point in the series' run. This episode focuses attention on Gary and Val, now divorced but negotiating the delicacies and complexities of an ongoing, intensely affectionate relationship. As they engage in a seaside talk about the past's impact on the present, Val laments "the mess of [their] lives" that they have made in California. Val also considers the potential impact of the present on the future: having made that mess, she deems Gary and herself "quite a pair," who "deserve each other." That language implies an eventual—but soap-operatically deferred—marital reunion. More striking, the conversation is one in which predictable crying gives memorable way to the much less expected, goofy, giddy (and perhaps improvised) laughing of Shackelford and Van Ark. It is also a conversation in which Val explains of her attachment to the ocean, "It never lets me down. It always helps me . . . *think*." Accompanying such words, the camera cuts between medium shots of the arm-clasping couple and longer, more meditative shots of the rhythmic ocean waves. Yesterday and tomorrow, apart and together, crying and laughing: the ocean indeed helps us *think* these phenomena. More specifically, the ocean helps us understand that such phenomena are not separate or opposed but blended, just as no easy or precise demarcation distinguishes the back from the forth of the tide, shown onscreen. The ocean participates in both diurnal and eternal orders: its movements

are simultaneously daily and endless. For this reason, the ocean becomes a vivid figure for the blending of recurrent, everyday time and open-ended, infinite time. That blending is central to the stakes and pleasures of a number of serial melodramas like *Knots Landing*. It is especially central to this milestone melodrama, which pioneered such stakes and pleasures for primetime with a uniquely middle-class spin. Chapter 1 makes space for further thinking about recurrent time, open-ended time, and their interplay: "And now . . ."

Funny Time, Stranger Space

Putting the "Spin" in Spinoff

The spinoff, as we recall from the Introduction, is a genre of television programming that capitalizes on the popular success of a prior series by drawing characters from that prior series into new situations. Working in this genre constitutes a tricky phenomenon, and its makers engage in a delicate balancing act. On the one hand, they develop a central premise, a set of scenarios, and an audiovisual style that recall the series that inspired the spinoff. In these ways, they give viewers a sense of continuity with that earlier series. On the other hand, they attempt to meet the expectation for something fresh, novel, and surprising. These two goals could be construed as working in direct conflict with one another. Thus the meeting of these conflicting, or at least competing, goals could be delineated by a formula: "more of the same, yet something else," which indicates the powerful ambivalence that marks the spinoff's relationship to its progenitor. The creative team behind *Knots Landing* responded with ingenuity to this ambivalent call, and their

ingenuity is registered, however unflatteringly, in the *Variety* review of the series' pilot. The review comprehends the achievement of "more of the same" when it describes the "spinoff from *Dallas*" as "retain[ing] [. . .] the raunchy behavior patterns and bad taste of the original." At the same time, the review sees *Knots Landing* as delivering "something else" in its use of "a middle-class frame of reference rather than the rich income background of the former's characters." The strategic upshot is that "[t]he possible," further "variations seem endless" (Knight 34).

At a further level of complexity, the spinoff will sometimes use *the very same elements* in its palette to serve up more of the same and to offer something else. In the earliest episodes of *Knots Landing*—still supposed to be reliant on the association with *Dallas* to generate viewer interest—this complex marriage of motives emerges in crossover scenes that integrate characters and histories from *Dallas* into the fabric of Seaview Circle. *Knots Landing*'s Gary Ewing is the favorite son of *Dallas*'s Miss Ellie (Barbara Bel Geddes) and the black-sheep brother of noble Bobby (Patrick Duffy) and wily J. R. (Larry Hagman). The movement from the pilot to the second episode, "Community Spirit," ratchets up the stakes of trading on these relationships. Inviting viewers to draw a terse but dense connection from *Knots Landing* back to *Dallas*, the pilot features Bobby in a brief, benign cameo as he helps Gary and Val move into their new house (with furniture bestowed by Miss Ellie). By contrast with this benign crossover approach, "Community Spirit" dispatches wicked oil-man J. R. to *Knots Landing* with an environmentally hazardous offshore drilling project, which Gary, Karen, and other picketing denizens of their seaside town oppose successfully. Here, we see "more of the same" in J. R.'s unethical schemes to make his big business bigger at any cost, maneuvers featured weekly in *Dallas*. Yet "more of the same" works precisely to inspire "something else," too: the social consciousness, represented chiefly by protesters Gary and Karen, with which characters respond to J. R.'s duplicity. That social consciousness draws *Knots Landing*

near to CBS's "relevance programming" of the earlier 1970s, epito-mized in series produced by Norman Lear's Tandem/TAT company (Lentz 46). It also draws *Knots Landing* away from *Dallas*, which either does not address social issues or incorporates flirtations with social issues in order to sensationalize them. The latter tactic is used pointedly in that Reaganite series as it also celebrates and glamorizes corporate greed.

In other words, *Knots Landing* reuses material from *Dallas*, yet it does so to eke a strikingly different ethos and politics from *Dallas*. For this reason, *Knots Landing* tips more to the side of fa-voring "something else" than to the establishment of "more of the same." And in yet more global terms, we could say about *Knots Landing* that its ambivalence toward *Dallas* is even more profound than the usual ambivalence of a spinoff to its so-called "parent" series. That is so because the relationship of this particular spi-noff to its parent series is more complicated than the family-tree description would suggest. *Knots Landing* was actually conceived *before Dallas* even though it came to the air later and was slightly retooled to appear as a development of the *Dallas* franchise. As the creator of both series, David Jacobs, has explained:

> When, in 1977, Mike Filerman [an executive at independent production company Lorimar] and I developed the idea of *Knots Landing*, there were no nighttime serials on television. When we presented the notion to Richard Berger and Kim LeMasters at CBS, they were intrigued, but hesitated [. . .]. Inasmuch as we would be breaking new ground, they said, could we come up with something on the same order, only glossier, more sensational, easier to promote—more saga than serial? (vii–viii)

Jacobs and Filerman answered that question with a resound-ing *yes* in the form of *Dallas* and had a bona fide hit on their hands with that series. As a consequence of this success,

the duo was later invited to reconceive *Knots Landing* as a *Dallas* spinoff, moving *Knots Landing* away from its initial imagining as something like the Swedish *Scenes from a Marriage* (SVT, 1973) for American television. Yet, in Jacobs's estimation, "*Knots Landing* was never comfortable" in the spinoff role (viii). That discomfort or awkwardness could have been construed as a deficit. Instead, as we shall see, *Knots Landing*'s production personnel capitalized exactly on the awkwardness of *Knots Landing*'s spinoff status in order to deviate in key ways from the *Dallas* model. One result of this deviation was *Knots Landing*'s ability to enjoy sustained popularity and record-breaking longevity.

At a more conceptual level, the awkward, exceptional spinoff series, imagined before its "forebear," can tell us a great deal about the nature of spinoffs in general, as an exception that proves some rules about the genre. It can also tell us a great deal about television production cultures and contexts more broadly. Interpreters of *Knots Landing* in its relation to *Dallas* not only ought to take account, say, of characterization, style, and tone—and how they differ in each series. They must also reckon with the economic determinants that are in part responsible for shaping decisions about these elements of television series. David Jacobs did not create either *Knots Landing* or *Dallas* in a vacuum but in response to specific, strategic input from CBS network executives. Those executives had direct ideas about how to soften the "breaking [of] new ground" through the compensations of "glossi[ness]," "sensational[ism]," and "eas[y] promot[ability]" of material to the mass audience that a major network could still hope to attract in the late 1970s. Moreover, these macro industrial influences on programming intersect trickily with more mundane, micro issues that we tend to regard as biographical details about series' personnel. (In fact, the latter details are as social or cultural as network practices and protocols.) Some of these micro details include the following: (1) New York-based writer Jacobs was impelled to move to California to be closer to a daughter

living there with his ex-wife, Lynn Pleshette. (2) Lynn Pleshette ran "a small literary agency," "became his agent," and helped to secure him work in television. Had these events not unfolded as they did, Jacobs might not have traded in "writing architecture book reviews for *The New York Times* and young adult things" for small-screen writing focused on issues of middle-class marrying, divorcing, and parenting—as well as on environmental and other progressive causes (Pleshette 2003). In other words, the networks, in the sense of the "Big Three," exerted a great deal of control in the late 1970s and early 1980s over circulating images of Left-identified, middle-class subjects. More pointedly, the networks exerted their control to *avoid* such images in primetime drama because of the images' perceived misfit in programming pitched to be "more saga than serial." But we must also keep in focus a related "network"—of agents, writers, actors, and directors who were also sometimes intimates. (*Knots Landing* actor and writer John Pleshette, for instance, was then and remains married to Jacobs's ex-wife.) This other network moved television in fresh directions by working gingerly within *and against* the constraints of the medium. When and how they could, such networked artists developed a body of work that refused, or at least challenged and complicated, the intoxications of luxury and escapism. That work included *Family* (ABC, 1976–80) and *Married: The First Year* (CBS, 1979), for both of which Jacobs wrote before creating *Knots Landing*. The latter series introduced him to eventual *Knots Landing* cast member Constance McCashin, whom he was excited to add to his network and continue to work with (Jacobs, quoted in "Museum of Television and Radio's 12th Annual Television Festival in Los Angeles: *Knots Landing*").

Knots Landing may be atypical as a spinoff conceived before the devising of the *Dallas* brand to which it owes CBS's ultimate interest in its development. Yet that atypicality merely brings into relief the inadequacy of the paternal metaphor—*Dallas* as "father" of *Knots Landing*, for instance—to describe most spinoff programming in a careful way. Rather than think

through the *off* of *spinoff* as suggesting "offspring," we might do better to hone in on the *spin* of *spinoff*. Doing so, we may reflect on the way in which television makers, as spinners or weavers, construct webs—and webs within and upon webs, constituting "networks" of connected objects. Understood in this light, *Knots Landing* and *Family* may be as "spun together" as *Knots Landing* and *Dallas*, as *Knots Landing* drew on *Family*'s investments in middle-class "average"-ness and topicality and transported those investments to a more aggressively serial and melodramatic version of primetime drama. This may mean that *Knots Landing* has a "familial" relationship to *Family* as well as to *Dallas*. Yet if so, the relationships are not rigid and linear: not "generational" but *generative*. Likewise, *Maude* (CBS, 1972–78) and *The Jeffersons* (CBS, 1975–85) are less the children than the respective cousin and neighbor of *All in the Family* (CBS, 1971–79). But *Maude* is also the respective funhouse twin of *Mary Hartman, Mary Hartman* (syndicated, 1976–77), and *The Jeffersons* is the kindred soul of *Good Times* (CBS, 1974–79) and *Sanford and Son* (NBC, 1972–77). And as these examples begin to suggest, the 1970s was an especially generative time for the development of spinoffs that do not adhere in generational ways to the series that precede them. *Lou Grant* (CBS, 1977–82) and *Trapper John, M.D.* (CBS, 1979–86) could also be cited as hour-long dramas, spun off from the half-hour *The Mary Tyler Moore Show* (CBS, 1970–77) and *M*A*S*H* (CBS, 1972–83), that deviated strikingly from those sitcoms at the level of tone, in narrative premises, and in the nonuse of characters (save the title ones) from the previous series.

Alongside these other spinoffs, *Knots Landing* helps to complicate notions about generation in television. More expansively, *Knots Landing* points toward questions about television and time, given the "funny time" it inhabits as a series that is simultaneously prior to *and* subsequent to the series of which it is an ostensible spinoff. Regarding the "priority" of *Knots Landing*,

the word indicates of course the consecutive order in which the worlds of *Knots Landing* and *Dallas* were first imagined. Just as important, though, is the "priority" of *Knots Landing* to Jacobs as he committed more to the meanings and values rooted in *Knots Landing*'s fictional world. In other words, *Knots Landing* takes priority over *Dallas* in Jacobs's mental life, in his working life, and in his affection. As he attests, "I didn't run *Dallas*, I ran *Knots Landing*. It was my fulltime job for 14 years: I was more like daddy. Whereas *Dallas*, it was my first and I was actually [still] working as a story editor on [. . .] *Family* when *Dallas* started and so I was a little removed from it. [. . .] My connection with *Knots Landing* is much tighter" (quoted in Jacobs 2003). *Knots Landing* is the series to which Jacobs is knotted, as it were, "much [more] tight[ly]." Yet it had to appear, at least at first and on the surface, as secondary to *Dallas*. That way of stitching the series together, largely a matter of marketing, unspooled dramatically over time as *Knots Landing* became a standalone success. And the final severance of the two series was accomplished with particular weirdness in the 1986–87 television season.

The Stuff That Dreams Aren't Made Of

Knots Landing inhabits "funny time" as a spinoff that birthed its forerunner and thereby its later self. But "funny time" was eventually *Dallas*'s province, too, when a year's worth of its narrative development was retrospectively (and infamously) reframed as character Pam Ewing (Victoria Principal)'s hyper-detailed dream. At the end of *Dallas*'s eighth season, Patrick Duffy left the role of Bobby to pursue other opportunities, and the writers capitalized on his departure to fuel an intense cliffhanger with Bobby's likely death in a car accident. The cliffhanger was followed by the confirmation of his death and the equally intense grieving of his loved ones at the beginning of the series' ninth season. But then Duffy's prospects for other Hollywood work

25

didn't pan out as spectacularly as he might have wished—and, at the same time, *Dallas* suffered because of increasing production costs dovetailing with decreasing ratings. In this context, Duffy was persuaded to rejoin the *Dallas* cast in order, it was hoped, to regenerate viewer interest in the series. Vying with the eye-popping twists and turns of the eighth-season cliffhanger, the finale of *Dallas's* ninth season traces waking Pam's movement from bedroom to bathroom . . . where she finds "dead" ex-husband and continued love Bobby showering. The shower scene offered a dual titillation for viewers, which hinged on the character's shirtlessness and, more basically, his aliveness. In turn, the tenth-season premiere of *Dallas* explains Bobby's reappearance, and thereby Duffy's return, in a manner unorthodox even for a serial drama whose viewers are used to outlandish narrative pivots:

> BOBBY: Pam? Honey, what's the matter? You look like you just saw a ghost.
>
> PAM: For a minute I thought I did.
>
> BOBBY: Now, what are you talking about?
>
> PAM: You—oh, Bobby, it was awful. When I woke up I thought that you were dead.
>
> BOBBY: What?!
>
> PAM: I had a nightmare—a terrible nightmare. I dreamed that you were here, and you were leaving, and Catherine was in her car, and she was waiting, and when we started to leave she tried to run me down, but you pushed me out of the way, and [*crying*] then she hit you, and she crashed into a truck, and she was killed, and then we took you to a hospital, and you died.
>
> BOBBY: Hey . . . Pam, I'm right here, and I'm fine.

PAM: Well, there was so much more, and, Bobby, it seemed so real. There was Sue Ellen, and there was Mark, and I was married.

BOBBY: [*laughing*] Yeah, you are going to be married—to me! Just as soon as we can.

PAM: [*crying*] I was so afraid. Oh, I love you so much.

BOBBY: Oh, honey, it's over. None of that happened. We're together, and I love you. *And* I'm getting you all wet.

PAM: Bobby, don't ever leave me.

BOBBY: I won't. I love you. [*They kiss.*] ("Return to Camelot, Part 1")

Viewers and critics might be likelier to construe the plot contrivance at the center of this scene, rather than dripping Duffy, as its truly "all wet" element—and many did. Yet all the same, we ought to appreciate the incredible *economy* with which the account of Pam's dreaming undoes an entire season's worth of storytelling and reboots *Dallas* to the fictional moment just prior to its eighth-season cliffhanger. Pam's dialogue is conspicuous for its string of many *and*s, connecting now-moot plot points, which could progress, it is suggested, almost infinitely. Yet her potential meandering is swiftly contained by Bobby's assertively delivered line, "None of that happened." That line emphasizes just how much earlier material is compressed in order to attempt to cancel the earlier material's impact.

The "dream season" that *Dallas* retrospectively produced had implications and effects for both *Dallas* and *Knots Landing* because *Knots Landing* had been responsive in 1985 to *Dallas*'s ninth-season cues before the 1986 dream season re-visioning

of material. Developed as a character with a great deal of affection for brother Bobby, *Knots Landing*'s Gary is represented as deeply mourning Bobby after the car accident causes Bobby's death. And when Val, divorced from Gary but still close to him, gives birth to twins, she names one Bobby to honor the dead Ewing brother. The executive producers of *Dallas* may have been willing to sacrifice a whole season's worth of developments to reintegrate Patrick Duffy into their cast, but not the collaborators behind *Knots Landing*. After seven seasons, the series had evolved sufficiently that its makers refused simply to follow *Dallas*'s lead—and so life in *Knots Landing* proceeded as though Pam had *not* dreamt a whole season and as though Bobby were still dead. At the level of production, the consequence was the abandonment of crossover episodes and only vague, minimal mentions of *Dallas* in *Knots Landing*: the latter fictional world was no longer coordinated to the former. At the level of reception, this decision was situated to produce cognitive dissonance for regular viewers and yet more committed fans of either or both series. Those viewers were asked to invest in one *Dallas* as they watched that series and to imagine another, parallel kind of *Dallas* as they watched *Knots Landing*—a spinoff that willingly and willfully estranged itself from *Dallas*. This set of effects may be profitably captured through the idea of "stranger space." The phrase describes the ways in which, after almost a decade, *Dallas* and *Knots Landing* became strangers to one another. It also registers how the space-time of *Dallas* became much stranger than that of *Knots Landing*. Precisely the *familiarity* of *Knots Landing* (compared with the increasing unusualness in *Dallas*) differentiates the spinoff and was designed and sustained to attract viewers. Indeed, such familiarity constitutes a form of respect for the abiding interest, pleasure, and dignity of those viewers, especially committed ones. Jacobs registers this respect for viewers in an interview where he offers this opinion of Pam's putative dream:

I thought that was a terrible decision, I always hated it. [. . .] I have killed off characters before and brought them back—I did that with Lisa Hartman—but I didn't like how it was done on *Dallas* because people were very emotional when Bobby died, and in a way when you say, "Never mind, it was all a dream," you are playing with their emotions in a negative way. I think they get angry. (Quoted in Jacobs 2003)

Here Jacobs refers to the firing and rehiring of Lisa Hartman, the actor who enjoyed a highly popular turn as singer Ciji Dunne in *Knots Landing*'s fourth season. Indeed, the character was so popular that her murder fueled an overwhelming wave of disappointment among series' fans. In response to fan mail attesting to this disappointment, Jacobs and his collaborators reintroduced Hartman as a different, lookalike character, Cathy Geary, in the series' fifth season. The resemblance of Ciji and Cathy was no mere coincidence to be swiftly explained away, like *Dallas*'s ninth season. Instead, it worked to recalibrate a number of character dynamics, to drive a variety of plot points, and to unleash a sequence of ripple effects in *Knots Landing*. At the center of these workings, scheming Abby Ewing (Donna Mills) "finds" lookalike Cathy precisely in order to capitalize on her resemblance to Ciji and on husband Gary's obsession with the dead singer. (Gary's distraction with Cathy will leave Abby freer to play fast and loose with their money.) Positioned like the producers themselves, Abby schemes in a way that nods smartly and winkingly to their behind-the-scenes capitalization on Hartman's return to the series. That winking nod to audiences constitutes an invitation for those audiences to treat their investments in the series as participating, rather than at odds, with the writers' imaginative play. Likewise, the possibility of Ciji and Cathy's uncanny resemblance—however implausible, from the perspective of strict realism—participates nonetheless

in a version of the real. In this fictional dance with the real, the irrevocable line between life and death has serious stakes. *Knots Landing*'s consistent endeavor to treat those stakes (and thus its viewers) as serious and real is instructive. It encourages us to weigh *Knots Landing*'s negotiations with Hartman and representations of Ciji and Cathy against *Dallas*'s negotiations with Duffy and representation of Bobby. When we do, we may reasonably see a cleavage. *Knots Landing* maintains a fidelity to reflecting the world as given, albeit in ways that richly stretch verisimilitude. By contrast, *Dallas* indulges an attraction to the occult and thus an eclipse of likeness to the world. (This cleavage is one to which *Knots Landing* even incites oblique attention. Late in the series' run, Val is presumed dead in a fierily explosive car accident, reminiscent of Bobby's earlier end. Yet the writers establish the right to "resurrect" Val—maintaining plausibly that she was never in the car—by following a principle that more fantastical *Dallas* is uninterested in following: if hedging bets about guaranteeing a character's death, *don't show the body*.)[1]

Writing of Pam's dream work in *Dallas*, Mimi White notes in passing how the dream work's "potential to infect" *Knots Landing* was avoided ("Women" 345). She also understands the dream work as contributing to a peculiar "memory effect" (344). When what "happened" in *Dallas*'s ninth season is revoked by its tenth, that material isn't *and nonetheless is* still part of the series' history, especially as that history is carried forward by remembering audiences instead of made awkwardly "unremembered" in *Dallas* itself. White builds on this insight about how recollection works in both more and less institutionalized ways. She proposes that the peculiar "memory effect" turns out not to be so peculiar after all. Rather, the extremity of *Dallas*'s maneuver merely exaggerates or extends an operation working "at the very heart of the soap opera genre more generally." The genre's standard bearers issue so much self-contradicting and self-revising material—so much material, period—that it is

inherently uncontrollable, subject to (potentially widely) varying retentions and manipulations (348–49). Alongside these standard bearers, *Knots Landing* may be less standard than some of the sister series and serials identified as "soap opera." Indeed, *Knots Landing* is arguably more scrupulous than other baroquely plotted, serial programs about the stewardship of its history. In the process, it is more regarding of its audiences' memories and lays a special claim on the value of continuity. This is just one facet of *Knots Landing*'s special handling and valuing of social relations as those relations unfold in *time*.

Telling Time

As White shows us, to think about television's time is to think about the time in a series, as well as the time of a series for viewers; it is also to think about memory and history. Based largely on the genres in which they work (or that they innovate), different television producers have different strategies for handling their series' memories and histories. Horace Newcomb provides a helpful taxonomy for thinking about these different strategies—and their potential to intersect. For the present purposes, we may put aside the episodic series (traditionally, sitcoms and procedurals) whose bounded installments require no strict memory of prior installments or sense of history. In each of Newcomb's other categories, we find some version (either more or less comprehensive) of *seriality*, the arrangement of episodes in a particular, necessary order to tell ongoing stories. On this spectrum, series featuring "cumulative" narratives are episodic but retain a memory of earlier episodes and refer to those earlier episodes, if sometimes only obliquely. "Arc" series develop two-to ten-episode narrative arcs. Soap operas generate wholesale seriality. And "multiple-story" series merge soap-opera and arc approaches. The resulting form features ongoing narratives with different lengths and moments of resolution (Newcomb 23–26).

Recall, in this context, Jacobs's ambition to produce daytime-inspired "serials" for an American primetime landscape from which such serials were absent. In turn, we may profitably use Newcomb's insights to trace the cultivation and evolution of seriality as it unfolded in *Knots Landing*. The series' first season moves from a cumulative narrative approach to an arc approach for the two-part season finale, "Bottom of the Bottle," discussed in this book's Introduction. A representative first-season episode like "The Lie" (episode four in season one) features a narrative that could be construed as "resolved" by the installment's end: Laura Avery (Constance McCashin) refuses to tell anyone, especially husband Richard (John Pleshette), that she has been raped, yet Val's insightful, final words to a distressed Laura give her a plan for carrying on. Likewise, the makers of *Knots Landing* themselves have a plan for carrying on that depends on remembering—and hoping that audiences remember—this episode's events, pivotal for the *cumulative* characterization of Laura. Here, the cumulative narrative approach is a temporary tactic to let audiences "get acquainted with" characters without expecting, so early in the game, painstaking recall or attention to more than a few episodes at a time. Yet the overall strategy was to incorporate seriality ever more fully into the primetime series form: that is, to draw nearer to the daytime soap operas that had so richly developed such seriality first in radio and then for television.

Once viewers may be presumed to know a reasonable amount about characters and to have invested in their accretive depiction over the course of a first season, the gamble in the primetime context to introduce an arc approach makes sense. In *Knots Landing*'s case, that gamble was successful enough not only to earn a second season but also to use the second season to deviate more boldly from the cumulative narrative approach and to embrace seriality more thoroughly. In other words, we can trace a paradigm shift from the first season (cumulative narrative culminating in arc narrative) to the second season (arc

narrative, punctuated every now and again by a cumulative approach to episodic plotting, cedes more and more ground to soap-opera seriality). This second season paves the way for the third season's full-on embrace of soap-opera seriality, intensified in subsequent seasons. On the same timeline, *Dallas* follows a very similar pattern of "ramping up" its seriality, indicating the attractiveness of such seriality not only to individual producers like Jacobs but also to the network that airs both series.

In part, the full-on embrace of soap-opera seriality in *Knots Landing*'s third season is enabled by a personnel change that could have been disastrous but is seized as fortuitous. Beloved actor Don Murray's decision to leave the series inspires the writers both to plot the death of his character, Sid Fairgate, and to make his widow Karen's *ongoing* grief, its permutations and evolutions, central to serial storytelling about how everyone in the cul-de-sac is affected by Sid's death. In part, personnel *input* motivates the fullness of the season's seriality.

At *Knots Landing*, actors were granted an unusual, generous level of access to Jacobs and his cohort of writers. In this context, Shackelford and Van Ark, wary of stasis and boredom, urge the development of another ongoing story: the breaking up of Gary and Val's marriage as a consequence of Gary's affair with Abby Cunningham ("Museum"). The subsequent intensification of this soap-opera seriality in the fourth season and beyond is a savvy response to the larger television ecology in which *Knots Landing* participates. NBC's competitor in the same time slot, *Hill Street Blues*, adopts a multiple-story approach focused on male characters. *Knots Landing* secures a loyal demographic, competitive with the *Hill Street* one, by taking a counter-approach, more fully serial and focused on women. Having achieved this demographic success, *Knots Landing* diversifies it through the masculine expansion of its serial appeals (introducing characters like Greg Sumner [William Devane], for example). Settling into this serial groove, monitored closely by Jacobs, works extremely well and for a strikingly long time. But

then a series of overlapping factors threaten the ongoing stability of the approach: (1) competition from *Hill Street* successor *L.A. Law*; (2) increased erosion of advertising revenue and network support; (3) Jacobs's professional investments elsewhere as he develops the series *Homefront* [ABC, 1991–93]); and (4) Jacobs's personal reasons (health issues) for inattention to the series' daily operations. This situation gives new show-runner John Romano a do-or-die opportunity for retooling *Knots Landing*'s thirteenth season (Jacobs 2003): in fact, in his hands a return to something close to the second-season design (arc plus cumulative narrative). That design, among other disagreeable aspects of storytelling and characterization, thoroughly displeases viewers and actors alike. In response, Jacobs initiates an unprecedented six-week break in production: a mini-hiatus

to plan a retreat from Romano's experimentation and a return to soap-opera seriality for the final season-and-a-half of *Knots Landing*. As discussed in the Introduction, the series' expensive production model is sustainable for just this long, given the careful management of high-paid series regulars' absences from episodes of the fourteenth season and Michele Lee's willingness to work some of the time at scale. Jacobs's rescue mission and decision to close with this fourteenth season enables a proper build-up to a satisfying series finale, a nonetheless open-ended resolution to what soap opera's historians would call the series' "world without end" (Simon et al.).

Describing the series' trajectory with this level of detail paves the way for some observations about duration and endurance, which are also matters of commercial success and popular appeal. One key takeaway from *Knots Landing*'s history: If the timing of seriality's execution and evolution is canny, audiences may *like* such seriality very much, feel inspired to loyalty by it, and understand its abandonment as a kind of betrayal. Such betrayal is correctable, though, through production personnel's attention and fidelity (like Jacobs's) on an order to match the audiences' own. As to why audiences may like

such seriality—and how *Knots Landing* put a particularly likeable stamp on it—fuller investigation is required. This includes a larger investigation of television's temporality. In Jacobs's retrospective assessment, *Knots Landing* "stayed on as long as it did because it captured a very steady audience, enough to ensure its renewal, a very good audience in terms of demographic, and [. . .] it stayed fresh" (quoted in Jacobs 2003). Yet that assessment raises further questions about the very nature of serial (and not just contractual) "renewal," the combination of "stead[iness]" and "fresh[ness]" that comforts audiences through familiarity and repetition even as it sustains their interest through novelty and surprise. The precise recipe for this combination of elements will, of course, vary from one series to another. In thinking through how the recipe worked for *Knots Landing*, I find instructive Thomas Elsaesser's general remarks—nonetheless applicable to this specific case—about what moves devoted television audiences and why:

> Locality, language, the conjugation of the day, the seasons and the generations, the respect for lived time, the television community of familiar faces and familiar spaces: this would be my starting point for judging [. . .] television, for it would imply an instinctive respect for the viewer, not just of his or her intelligence, interests and need to be stimulated and entertained, but of his or her existence as a physical as well as a social being. [. . .] Tactility, making contact [. . .] may command that highest of accolades, which is not peak viewing figures, but viewer loyalty [. . .]. ("Zapping" 62)

One crucial factor in the achievement of "viewer loyalty" is "the respect for [the] lived time" of the viewer "as a social being": respect for time's measurement in "day[s]," "seasons," and "generations" *as* social time. Thus television that respects

social time *by counting it and accounting for its value* will be poised to achieve such viewer loyalty. All television involves the management of time as a social phenomenon.[2] Yet not all television avows the management of social time or develops specific formal codes and cues to mark the avowal. *Knots Landing* did, and for so doing, it reaped the reward of viewer loyalty that Elsaesser privileges.

To understand this "marking" that *Knots Landing* does— and that makes it *re*markable—requires first understanding what makes it typical. *Knots Landing* is in some ways very much like other serial dramas in the melodramatic tradition. It takes, for instance, a familiar approach to establishing "still time" and "automatic time." These two kinds of time, according to Richard Dienst, come together to constitute the television apparatus as such. "Still time" comes most intensely into view in the "diffracted slices" or cuts of commercials and music videos (160), which "[demand] that we keep switching" (168). "Automatic time" is most vivid in "live" event coverage (163) that "demands that we keep watching" (168). Dienst comprehends still time and automatic time as television's most significant "time scales." He is also careful to note that they work "before and beyond the operations of memory, representation, or narrative" (xii). Therefore television time resists to some extent analysis as "content." Yet in Dienst's close reading of the series *Crime Story* (NBC, 1986–88), he interprets that series as "bring[ing] various chronologies into instant adjacency" (78). Thus he provides a model for thinking about what kinds of time other, specific series make "adjacent[t]" to each other. In the case of *Knots Landing*, an open-ended serial melodrama, time management is driven by the interplay of untroubled, "still" moments (for example, a freeze frame on a mother reunited with her kidnapped children) and turbulent, "automatic" movements (for example, a scramble to cars launches a chase in which one of the kidnappers may escape). The still moments feed our fantasies of stasis in the form of peace, happiness, or exaltation. The turbulent

movements acknowledge the likely pain entailed by dynamically passing time: passing time renders loss.

Yet, as I suggest above, *Knots Landing* does more than produce these adjacent kinds of time. The series also grafts other content onto still and automatic scenes. And that additional content works relentlessly to *calculate or name* the series' kinds of time. One example comes from episode titles (notably, they are overlaid directly on episodes' opening scenes in a deviation from standard period practice). Literally dozens of these episode titles mark the passing of time. They disclose the manners—sometimes quotidian, sometimes curious or exceptional—in which that time passes, from "Night," "The Morning After," and "Yesterday It Rained" to "The Longest Day," "One Day in a Row," and "Out of the Past." Likewise, incidental dialogue turns with staggering frequency to the passing of time and to the business, domestic, and leisure relations that time's passing coordinates. These measurements of time may be—Banal: "I really had a lovely evening." Promissory: "We'll play with the trains in the morning." Searching: "What do you do at ten o'clock at night when you want to talk and can't drink?" Anxious: "When is Mom coming home?" Impatient: "Are you gonna let that phone ring all night?" Careful: "We're moving very slowly so we don't give them any reason to pull a trigger." Rueful: "Buddy, you've got bad timing." Nostalgic: "I was fifteen when I met her. When she smiles or turns her head a certain way, I get a glimpse of how she used to be." Memorializing: "Remember the hot tub?" Comical: "Are we lost?" "I think we are, darlin'." "Yeah, but we're making great time!" Hopeful: "I promise you that there are better times to come." Winking: "You keep the books, and I'll marry Gary—and, I'll do it before next week"—or abundantly otherwise.[3] In these ways, *Knots Landing* keeps time in order to produce a special effect: the series tells us how it recognizes and values all the acts, feelings, and moods that time keeps in its ampleness.

Coda: Full House

Knots Landing's unique version of measuring social time ought to be thought of on a spectrum with the ways that it measures social *space*. More particularly, the series brings insistent attention to the spaces it televises the most, the interiors and exteriors of the cul-de-sac's houses. These spaces are not only private but also public—just like television itself, the ostensibly quintessential medium of the home that mediates doggedly between the domestic and the commercial, the personal and the political, the intimate and the unfamiliar. The insistence in *Knots Landing* on space's social character will come more fully into focus in chapter 2. There, I offer an examination of two series elements—surveillance and neighborliness—that overlap with complexity. That effort will coincide with a consideration of middle-class suburbanization because suburbanization shapes social space forcefully as that space becomes both neighborly and paranoid. En route, I pause here for one moment of "still time"; or, to mark one way in which time and space come together to pronounced effect in *Knots Landing*. Because time spent in spaces thickens those spaces, the suburban houses of the cul-de-sac become, in and of themselves, *characters* in the ongoing drama of Seaview Circle. This capacity of *Knots Landing*'s houses to turn into vibrant matter—to acquire something like lives of their own—is intimated at the end of "Night" (episode nineteen in season three). During the installment, a S.W.A.T. team has had to rescue Laura and her young son from the house in which unhinged husband Richard has held them hostage. On the heels of this successful mission, "Night" declines to close on an expected scene of the episode's central characters. Rather, a crane shot, moving somewhat vertiginously from street view to bird's eye view, frames the Avery *house* in a final, dawn tableau. That camera movement is conspicuous for figuring the building at a less characteristic angle than other establishing or location shots of its exterior. In this

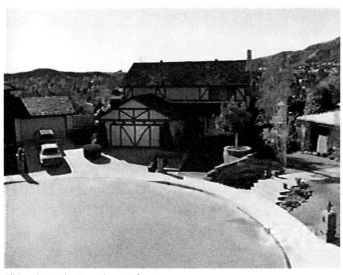

All is quiet at the Avery house's front.

way, the camera movement calls uncanny attention to the house and to its weird emptiness as resonant, haunting, haunted . . . and thus paradoxically *full*. We may read this ambiguous shot either as suggesting the restoration of order and peace or as suggesting the possibility for further eruptions of disorder and danger at this site. In either case, the house itself has crept into mind as *vital* in both senses of the word (important, alive). As "Middle-Class Movements" will demonstrate, such effects are consistently possible for *Knots Landing*'s producers to create. They anticipate that a statistically sizeable audience will identify with the cul-de-sac's split-level and faux-colonial houses, much more than *Dallas*'s mansions, as their "own."

Middle-Class Movements

Corporate Structures, Tragic Structures

When *Knots Landing* severs its ties to *Dallas*, as discussed in chapter 1, the severing is accomplished in the immediate interest of fidelity to a season's worth of its storytelling. Yet that immediate intention could also be understood as a local reflection of a larger conceptual difference between the middle-class ethos of *Knots Landing* and the ethos of *Dallas*. As also discussed in chapter 1, *Knots Landing* is indebted to pioneering work done in *Family* as it establishes a related, serialized focus on middle-class lives and concerns. Yet at the same time, and in the very different televisual landscape of the 1980s, such a focus has more pressing stakes for the ways that it provides a contrast to other primetime dramas alongside which *Knots Landing* airs. These other dramas, inspired by *Dallas*'s success, glamorize the lives of the super-rich and dominate network airwaves in the 1980s. (Such series include, most notably, *Dynasty* [ABC, 1981–89], its spinoff *The Colbys* [ABC, 1985–87], and *Falcon Crest* [CBS, 1981–90].) The contrast or conceptual difference in question is registered at the level of tone and style; it enables *Knots Landing* to adopt alternative strategies

for narrative and characterization; and, in the process, it also enables *Knots Landing* to accomplish different ideological work from the other major dramas of its period. Jane Feuer captures vividly the common features of those other series:

> [S]erial form was the aesthetically dominant narrative innovation of [1980s television], while the typical conflicts of domestic melodrama came to represent the decade's central ideology in the way it condenses the corporation and the family—the mainstay institutions of Reaganism—into a single representational unit in the form of what I will call the "corporate family." [. . .] Both *Dallas* and *Dynasty* deal with the economics of multinational corporations, but they do so in terms of the familial conflicts that control the destinies of these companies. This is typical of the domestic melodrama's oft-noted tendency to portray all ideological conflicts in terms of the family. However, *Dallas* and *Dynasty* also depict the family in economic terms, thus apparently demystifying the middle-class notion of marriage based on romantic love [. . .]. (115, 123)

Knots Landing is deeply invested in the specific "middle-class notion of marriage based on romantic love," a value that is rather questioned (if only implicitly) by series like *Dallas* and *Dynasty*. More generally, *Knots Landing* takes middle-class values as a touchstone, and thus develops a different ideological relationship not only to "marriage" and "romantic love" but also to "the corporation" so "central" to "Reaganism." Beginning in 1983 (and for the rest of the series' run), *Knots Landing* indeed addresses "the economics of multinational corporations" in a departure from earlier seasons' focuses on other issues. Yet when *Knots Landing* looks to the corporation, it does not do so centrally through the "condens[ing] [. . .] representational unit

[. . .] of [. . .] the 'corporate family.'" And it certainly does not work in the basically affirmative mode with which Reaganite series like *Dallas* and *Dynasty* salute "the economics of [such] corporations."

Instead, *Knots Landing* performs a different but related "condensation." The series makes its ideal representatives of romantic love unfolding in stable marriage—Karen and second husband Mack Mackenzie (Kevin Dobson)—also its chief opponents of corporate greed and malfeasance. We see this opposition in the respective forms of social justice (Karen's activist work) and legal justice (Mack's professional work, especially as governor's special investigator) with which the couple regularly confront such greed and malfeasance. In other words, Mack and Karen are married happily not just to each other but also to a shared commitment to crusade against wrongdoing, especially in its Reaganite economic guises. Made sympathetic in this manner, the couple is thus positioned to provide a continuous point of identification for audiences. By contrast, a series of corporate lone wolves (Mark St. Clair, Scott Easton, John Coblenz, Reuben Pomerantz, Nigel Treadwell) and the companies that they represent (aptly named Wolfbridge Group, Galveston Industries, Oakman Industries, Treadwell Industries)—quite different from the corporate *families* of other series—are more or less interchangeable, repellent evildoers. Representing a lone agent of evil like the ones named here is a trick as old as melodrama itself. (Think of the stereotype of the mustache-twirling villain on the nineteenth-century stage.) Moreover, melodrama has been routinely *criticized* for showcasing these villains, who suggest misleadingly to audiences that the sources of evil are individual, personal, and psychic rather than economic, social, and political (Williams; Singer). At first blush, it would seem that *Knots Landing*'s parade of "lone wolves" could be subject to the very same critique. Yet a more careful look suggests an alternative interpretation. The representation of this *series* of lone wolves is specific to television melodrama, which features such

43

villains (in *Knots Landing*'s case) for over a decade rather than for a couple of evening hours in the theatre. The cumulative effect is to figure the villains, far from individually pathological, as instead essentially substitutable. Further, this effect works to point away from "singular" evildoers and toward their equally substitutable *corporations* as the sources of corruption and devastation. In case audiences miss this point, Mack underlines it in a conversation with "powerful" Gary in "Until Parted by Death" (episode nine of season seven):

> It bothers me that I spent years investigating the Wolfbridge Group and Galveston Industries, and no one goes to jail for it: all I get is some two-bit, baby-stealing lawyer. Penny-ante stuff! [. . .] I put Wolfbridge out of operation *here*. They're cockroaches, they avoid the light, but you can bet your bottom dollar they're in operation somewhere else, somewhere where the people are less informed, less powerful.

A "two-bit, baby-stealing lawyer" like minor character Scott Easton (Jack Bannon) is rendered without much complexity. In turn, two major characters, Abby and Greg, are worth comparing with these more peripheral, corporate lone wolves. On the one hand, these two scheming characters form tactical, often messy alliances with the lone wolves and are thus "like" them to some extent. On the other hand, Abby and Greg's characterizations are nuanced by their family attachments—ones that encourage their occasional efforts to manufacture the "corporate family" structures that Feuer describes as central to *Dallas* and *Dynasty*. Importantly, Abby and Greg find that those efforts can never be made stable or sustained. This frustration of their "corporate family" designs works to highlight the fundamental incompatibility of corporate allegiances and family allegiances in *Knots Landing*'s fictional world. In other words, *Knots Landing*

dispels the myth of the corporate family. And it does so in order to valorize and to insist on the contrasting, non-mythical *realness* of the middle-class family. This realness is made palpable and material in (for instance) Mack's "Kiss the Cook" apron or in the sensible handbag that Karen seems always to be saying she must grab.

As we saw in chapter 1, *Dallas* deviates strikingly from realness and, more broadly, from realism when it solves a narrative problem through dream work. In a more ongoing way, *Dallas* departs from realism in the fantastical representation of the corporate family—and, to boot, in depicting all the family's members living improbably under one roof, as Feuer notes (116). Yet *Dallas*'s creative team is not troubled by such deviations from realism because the series' agenda is itself untroubled by them. Indeed, *Dallas*, unlike *Knots Landing*, is not tethered in its substance to television realism. The claim on realism that *Dallas* stakes may be bracketed, so long as the series' "tragic structure of feeling"—one that it *shares* with *Knots Landing*—is maintained. Writing about audience responses to *Dallas*, Ien Ang defines the tragic structure of feeling in this way:

> It is emotions which count in a structure of feeling. Hence emotions form the point of impact for a recognition of a certain type of structure of feeling in *Dallas*; the emotions called up are apparently what remain with the [viewers] most. [. . .] What we can deduce from [the viewers' testimony] is the notion that in life emotions are always being stirred up, i.e., that life is characterized by an endless fluctuation between happiness and unhappiness, that life is a question of falling down and getting up again. This structure of feeling can be called the *tragic* structure of feeling; tragic because of the idea that happiness can never last forever but [. . .] is precarious. [. . .] Life presents a problem according to the tragic

structure of feeling, but that does not mean that life consists solely of problems. On the contrary, problems are only regarded as problems if there is a prospect of their solution, if, in other words, there is hope for better times. (45–46)

By this logic, realism may not matter so long as "emotions [. . .] count." So long as audiences *feel* such emotion as they watch characters "falling down and getting up again," living with "hope for better times," then realism may become a matter of minor concern, if not immaterial. (And isn't emotion, counted and counting, as well as hoping for better times, at the heart of Pam's dialogue when she wakes from her "dream" and tells Bobby, "I love you so much," "don't ever leave me"?) *Knots Landing* participates just as intensely as *Dallas* in a tragic structure of feeling, yet with a different, middle-class emphasis. As I have been suggesting, this middle-class emphasis is also part of *Knots Landing*'s grounding in realism. Thus, in order to understand the exact kind of realism the series embraces, we must also explore further its middle-class concerns.

Cook-Kissing, Pressure-Cooking

Knots Landing's fundamental investment in realism may be understood more specifically as an investment in "soap opera realism." Marion Jordan defines this brand of realism in a pioneering essay on the nominally working-class British serial *Coronation Street*. According to Jordan, soap opera realism is a hybrid style that results from the adaptation of social-psychological realism—as it would guide, say, a novel or play—to the particular exigencies of television seriality. This seriality commands fuller melodrama from narrative situations and events than we find in less open-ended, realist fictions. Like those fictions, soap-operatically realist television programs "have as one of their central concerns the settling of people in life;

[. . .] settings [that are] commonplace and recognisable [. . .]; the time [of] 'the present'; [and a] style [that] suggests an un-mediated, unprejudiced [. . .] view of reality" (28). Less like those fictions, this programming is also heavily motored by the melodramatic interplay of the sensational and the sentimental. Sensationalism generates narrative suspense, and sentimental-ity gives that suspense emotional weight, texture, and color. In other words, programs like *Coronation Street* and *Knots Landing* tend to *stretch* social-psychological realism, so that this realism acquires more sensational and sentimental qualities. Or, to look at it from another perspective, we could say that realist serials *ground* melodrama's extremes. These works locate melodrama's sensational and sentimental excesses in everyday worlds that are otherwise socially and psychologically realistic.

As indicated above, the specific version of soap opera re-alism that *Knots Landing* offers is doggedly middle-class. This middle-classness distinguishes the series from most earlier primetime dramas (as opposed to domestic sitcoms) and from the dominant dramas of its own era (*Dallas*, *Dynasty*, and their kind). More complicated, *Knots Landing remains* doggedly mid-dle-class even when characters like Gary and Laura appear to leave middle-class formations by receiving a huge inheritance or by marrying a corporate titan, respectively. In other words, the saturating middle-classness of *Knots Landing* is transformed but not undone by characters' economic mobility. Jacobs refers to this key attribute of the series when he writes of a turn that *Knots Landing* takes in its fourth season (the time, among other developments, of Gary's financial windfall upon the death of his father):

> We started making [some of] our characters richer. We took them out of the cul-de-sac and put them in the corridors of power. People got threatened, blackmailed, murdered. [. . .] But the funny thing was, though we changed *Knots Landing*, we didn't

47

really make it different. Its heart and substance remained middle-class, its base familiar. [. . .] We keep people ordinary. Ordinary people in extraordinary circumstances. (viii)

This account helps us to understand the shifting tactics but unchanged strategy of *Knots Landing's* production. Responding to the account, I use the term "middle-class movements" to describe a series of overlapping features (including characters' economic mobility). "Middle-class movements" define *Knots Landing* and make of its "ordinary" / "extraordinary" axis a special case in television history.

First, let's circle back to Jordan's account of the hybrid that melodrama and realism form in "soap opera realism." In turn, we could say that middle-classness as a feature *moves*—makes itself pliable to—both the realism and the melodrama of *Knots Landing*. On the one hand, episodes devote whole scenes to realistically quotidian conversations and their engagement of the objects of everyday, middle-class life. One classic example: a humorous argument between Mack and Karen about the best way to put a roll of toilet paper on its dispenser. (Karen's "over-the-top" approach clashes with Mack's "under"-orientation.) This conversation would be preposterous in *Dallas*, *Dynasty*, *Falcon Crest*, or any of the other 1980s series trading more singularly on glamour. Those series would never consider mundane patterns of consumption and how such patterns become rituals. By contrast, *Knots Landing* focuses attention on the repeated, ritual comfort that Val and Karen take from the humble act of ordering pizza as they face grievous problems together. Challenging Samuel Beckett's famous pronouncement that "habit is a great deadener," *Knots Landing* shows us how habit may instead *enliven* situations and relations (59).

On the other hand, middle-classness also informs the melodramatic part of *Knots Landing's* hybrid style. Its episodes explore what happens when melodramatic feelings play out not

on the lavish scale of a series like *Dallas* but, for the most part, in the more modest, middle-class spaces of the suburban cul-de-sac. Working on this smaller scale has an effect that might be surprising or even seem paradoxical: the stakes of relationships and conflicts are not muted or dampened but rather ratcheted up. Seaview Circle forms a neighborhood where everyone can—and does—watch everyone else; characters are relentlessly figured at the windows that face the street. In this environment, tender friendships and genuine support systems develop, but a complex choreography of surveillance also develops. As a result, every overheard word, every observed action, and every mundane motivation acquires powerful meaning. Imbuing the mundane with powerful meaning is the central feature of what Ang names not the tragic structure of feeling but rather "the melodramatic imagination":

49

> The melodramatic imagination is [. . .] the expression of a refusal, or inability, to accept insignificant everyday life as banal and meaningless, and is born of a vague, inarticulate dissatisfaction with existence here and now. This then [feeds] the tragic structure of feeling: it is not about the great suffering which plays such a prominent role in the history of humankind and which is generally known as human tragedy—the sufferings of war, concentration camps, famine, etc.—but is rather about what is usually not acknowledged as tragic at all and for that very reason is so difficult to communicate. There are no words for the ordinary pain of living of ordinary people in the modern welfare state, for [their] vague sense of loss [. . .]. By making that ordinariness something special and meaningful in the imagination, that sense of loss can—at least for a time—be removed. It is in this world of the imagination that watching melodramatic soap operas [. . .]

can be pleasurable: *Dallas* offers a starting point for
the melodram atic imagination, nourishes it, makes
it concrete. (79–80)

As Ang suggests, a series like *Dallas* could be understood as
"making ordinariness [. . .] special and meaningful." The saga
renders "insignificant" matters—alcoholism, adultery, miscar-
riages, and so forth—*more* significant because it sensationalizes
and sentimentalizes them. Yet *Dallas* has a built-in shorthand
for this transformative process. "Significance" comes from the
extraordinary world into which "everyday life" events are trans-
lated and from the extraordinary richness of the characters who
experience those events. By contrast, *Knots Landing* does not
transform banality by dislocating it to a superficially glossy,
"enchanted" place. All the same, *Knots Landing does* transform
banality—instead by *re*orienting our view of the spaces where
we expect banality to unfold: for instance, in the suburban cul-
de-sac. Doing as much means to perform an arguably more
impressive, because trickier, magic act. *Knots Landing pressur-
izes* the ordinary's flesh and bones into extraordinariness rather
than costuming the ordinary in extraordinary clothes. Such
pressurization, enacted repeatedly in *Knots Landing*, comes into
especially clear view in "China Dolls" (episode twenty-one in
season three). That installment is one of the many, referenced
above, in which watching from windows is key. In "China
Dolls," the central acts of surveillance, performed by various
parties with competing motivations, are prompted by Gary's
affair with Abby, just about to be discovered by Val. Also cen-
tral to the episode is the title metaphor of the fragile object:
"We're all just china dolls," a minor character says of human
frailty. The china doll is an "artificial" metaphor that collides
with a "natural" one, thunderclouds. "Looks like we're in for
some stormy weather," we hear as these thunderclouds fill the
cul-de-sac and as the danger associated with the affair escalates.
Other metaphors for the affair, its implications, and its possible

consequences pile up dramatically over the course of the episode (gambling, blooming versus dead flowers, and more). Yet the episode is very knowing about the seeming excess of these metaphors. Through its knowingness, the episode tells us that no one metaphor, no one interpretive framework, can capture the emotional and ethical intricacies of the narrative or its heightened stakes for the characters. Instead, each of the metaphors falls apart under the strain of their cumulative weight. And that effect of collapse foreshadows more powerfully than any metaphor could, on its own, the collapse of the Ewings' marriage. In this context, viewers may feel the excruciation, the near-unbearable charge, of such pedestrian acts as crossing the street to knock on a neighbor's door. The ability to discern the ordinary from the extraordinary is made as unavailable as the answer, for Val, to her question of Abby: "Are you and my husband having an affair?" "I'm not saying we are, and I'm not saying we're not. I *am* saying I can have him any time I want."

As If

In a conceptual way, *Knots Landing* differs from *Dallas* by not "costuming the ordinary in extraordinary clothes." Yet at a literal level, the wardrobe department at *Knots Landing did* dress actors playing "ordinary people," as Jacobs describes them, in extraordinary clothes. And these "ordinary people" are especially well dressed as the characters move into what Jacobs describes, in the same breath, as the "corridors of power" (or at least the corridors of parties thrown by the powerful). As noted above, major characters do routinely leave the cul-de-sac, and their leave-taking is not always, but mostly, to swankier addresses. These departures form a second "middle-class movement" worth attention. To be sure, characters *move* up (or, less frequently, down) the economic hierarchy. Yet at the same time, middle-classness persists as a lingering feeling, a residual point of identification, or an animating spirit in the series'

representations of wealth or poverty. In Jacobs's language, *Knots Landing* "keep[s] people ordinary"—and thereby, it is presumed, relatable, whatever their given economic circumstances.

There is, however, a more precise way to conceptualize this effect than to call it "keeping people ordinary." When characters who are not technically middle-class nonetheless express behavior that seems or feels middle-class, they exhibit *theatricality*: a display or performance *as if* they were middle-class. We see this middle-class "as-if-ness" persisting at a number of nonsuburban sites, including Westfork (Gary's tony ranch), Abby's Malibu mansion, and the country estate where Greg and Laura eventually make their home as a married couple. At Westfork, for instance, Bobby and Betsy's mass-market toys are strewn on the floor of the capacious den. Or Greg builds a backyard playhouse for daughter Meg, even though "backyard" is hardly an accurate word to describe the large, carefully groomed outdoor space behind his house. (The playhouse makes that space *feel*, temporarily, like a backyard. And the eventual burning of the playhouse, after the death of Meg's mother Laura, symbolizes not only Greg's severance of his parental obligation to Meg but also the dissolution of any middle-class feelings and values that might have been associated with his marriage and parenting.) Perhaps most pointed, we cut to a montage of scenes of Abby after wealthy lover Charles (Michael York) asks her how they might spend a perfect day. The montage features the predictably luxurious horseback-riding on a private beach; yet that activity is bookended—and its luxury is undercut—by a game of foosball in a dive arcade and a lobster dinner consumed not, as we might expect, in a high-end restaurant but at a seafood shack that supplies its customers with kitschy, disposable bibs ("Only 'Til Friday," episode thirteen in season nine). In these scenarios, replete with theatrical props, middle-class as-if-ness pervades *Knots Landing*'s spaces, however far those spaces may be from the cul-de-sac's orbit. To understand this theatricality in a broader critical context, we might look to the work

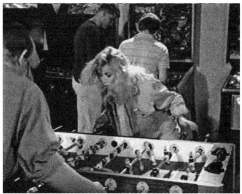

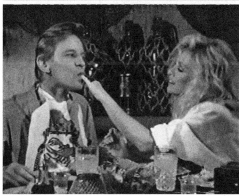

Abby plays foosball, rides horseback, and feeds lobster to her bibbed lover.

of theatre historian Andrea Most. She describes an American moment of a half-century earlier when historical actors (and fictional characters) strove to shed ethnic baggage and repudiate working-class origins through theatrical behavior. These actors and characters aspired to middle-class success, as yoked to the myth of the so-called "American dream." Most captures the logic behind their behaved theatricality in a formula: "If you can do it, you can *be* it" (547). As a key 1980s successor to these earlier performances, *Knots Landing* reverses their logic. This reversal makes sense, given *Knots Landing*'s substitution of rich characters maintaining middle-class affiliation for poor characters angling for middle-class status. *Knots Landing* suggests: "If you *are* middle-class" in what Jacobs calls your "heart and substance," "you can *do* middle-classness" in any context or situation.

It is not incidental that so many of the "props" named above are items associated with childhood games and pleasures and, yet more tellingly, with parenting. Various influential ideas about proper child rearing have been advocated in Anglo-American middle-class formations since the mid-nineteenth century. Indeed, middle-class reformers have for a long time claimed the philosophy of proper child rearing as their special province. Appropriately, then, Abby is never at her most theatrical, middle-class best than when she deals with the cocaine addiction of daughter Olivia (Tonya Crowe). She marks their house as a space for reflexively performed "good" parenting— a literal stage for maternal intervention—by announcing that she will "lock [Olivia] in" rather than, as Olivia expects, kicking her out ("The Unraveling," episode sixteen in season eight). Given the generally Left-leaning orientation of *Knots Landing* that I sketch in a number of ways, we might be surprised by this narrative. Why should a storyline designed especially to humanize devious, scheming Abby align with the conservative ideology of the Reaganite "war on drugs"? In answering this question, we might look to Mimi White's persuasive work in an

essay on television and ideology. On the heels of a brief invoca-
tion of *Knots Landing*, White argues that any "given program"
(especially a long-running one fueled by many collaborators'
input) will "develop variable perspectives and issues over time.
[. . .] [W]ithin a single episode, across an evening of viewing,
or over a season's worth of episodes of a particular program,
the production of ideology may emerge as variable, slippery, or
even contradictory" ("Ideological" 181). As *Knots Landing*'s chief
representative of neoconservatism's 1980s ascendancy, Abby is
rarely positioned as a figure for strong viewer identification,
like Karen. Rather, she often comes into direct conflict with
Karen, and she contrasts pointedly with Karen in two key ways:
(1) She espouses different politics from Karen, whom Jacobs
describes as "the person who expressed my personal feelings on
issues, [. . .] the one most like me, [. . .] the one I most identified
with" (quoted in Jacobs 2003). (2) And she travels in different,
more corrupt professional worlds from Karen, who represents
"[t]he New Class, as defined by [. . .] neoconservatives"—"that
part of the professional middle class that finds an occupational
home in the media, in the public sector, and in the nonprofit
world exemplified by the university, the foundation, the social-
welfare agency" (Ehrenreich 197). All the same, any account of
Knots Landing's roadblocks to identification with Abby must be
tempered. As Sandy Flitterman-Lewis maintains (like White,
on the heels of a brief invocation of *Knots Landing*), "there is no
ending point in soap operas, no moment of ultimate closure in
light of which an actor can gauge his/her performance or the
viewer can locate a relationship with that character. Soap operas
encourage multiple identifications with characters by keeping
those characters perpetually open to change" (232). Some of
the pleasure and *roundedness* of serial melodramas comes from
the possibility that characters like Abby can emerge, if only
transitorily, as sympathetic.[4]

No 1980s series as thoroughly invested in "the middle"
as *Knots Landing* could become such a middle-class milestone

without taking stock of that class's own roundedness: its "variable, slippery, or even contradictory" dimensions. Inevitably, then, the series would have to take stock of the "indiscriminate hysteria over drugs [. . .] at the heart of the [1980s] middle class" ethos, fueled by "the fear [. . .] of losing control, of growing soft." Writing in the late 1980s, Barbara Ehrenreich interprets this "hysteria over drugs" as a symptom of a larger problem:

> "Drugs," as an undifferentiated category, symbolize the larger and thoroughly legal consumer culture, with its addictive appeal and harsh consequences for those who cannot keep up or default on their debts. It has become a cliché to say that this is an "addictive society," but the addiction most of us have most to fear is not promoted by a street-corner dealer. The entire market, the expanding spectacle of consumer possibilities, has us in its grip [. . .]. (247)

In the representation of Olivia's cocaine use and its effects, *Knots Landing* does more than depict the class-inflected hysteria that Ehrenreich describes. Whether fully witting or not, the series also nods in the direction of an analysis very much like Ehrenreich's own. Like Ehrenreich, *Knots Landing* positions drug use as just one version of conspicuous consumption. And, like Ehrenreich, the series shows us how hand wringing over drug use provides an alibi for ignoring other, troubling aspects of capitalism. Once Abby has "lock[ed] [Olivia] in," the willful daughter retaliates by smashing domestic objects—most notably, an expensive vase—until Abby "give[s] [her] the keys" ("No Miracle Worker," episode seventeen in season eight). With these gestures, Olivia calls attention to what Abby would have the teenager ignore: her own patterns of consumption, her own enthrallment to the "spectacle of consumer possibilities." We might conclude that Abby does not, exactly, fear Olivia's potential for escalating, violent behavior. Instead, she may fear more

material damage on the order of vase smashing. With that damage would come the loss of propriety's semblance, so prized by middle-class-identified subjects. Abby may, as I have suggested, be a figure positioned here for sympathy or identification, but she is also available to be read more critically.

Rising Fall

Elaborating middle-class "as-if-ness" is, then, a crucial aspect of *Knots Landing*'s addresses to its audiences. In the process, the series follows and shores up a quintessential logic by which the American citizenry—and not just Americans as television viewers—were hailed from the late 1970s through the early 1990s. For powerful ideological reasons, politicians of all stripes addressed the overwhelming majority of Americans in this period, regardless of their real economic situations, *as if* they were middle-class. (As we shall see, this strategy has been adapted, though not meaningfully altered in its substance, in the intervening decades and is still prevalent.) A similar strategy marked the American politics of the 1950s. In that period, a rising, suburbanizing, postwar middle class could plausibly be targeted as dominant. Moreover, that class was targeted as the perfect constituency for the period's major ideology, which advocated gendered divisions of labor, new patterns of consumption, and rabid anti-communism (Spigel). Yet this strategy of addressing the middle class was—again, across the political spectrum—largely abandoned in the 1960s and '70s. Then, for instance, some Left factions oriented their politics toward a nostalgically imagined working class, a "great [. . .] enterprise of image-making and social 'discovery'" (Ehrenreich 121). Rightists like Nixon made differently tailored appeals to poor white and Catholic voters (Greenberg 121).

In 1980, the Reagan campaign's genius was to "rediscover" the electoral magic in "appeal[ing] to the middle class," not just the wealthy, "as victims of excessive taxation" ("Middle Class

Blues" 14). Similarly, in 1984, the Reagan camp portrayed opponent Walter Mondale as "only too anxious to pick the pockets of the middle class. Reagan used the tax issue to take himself into the economic struggles of ordinary voters and put a wedge between the Democrats and the middle class" (Greenberg 135). On the other side of Reagan's disastrous economic policies, Bill Clinton could wrest back for Democrats the claim to be the party of the middle class. (This rhetorical goal was attempted but unachieved by Ted Kennedy in his address at the 1980 Democratic national convention [Greenberg 119–20].) Most notably, Clinton announced his presidential candidacy in a 1991 speech in which he also hailed "*the forgotten middle class*"—so different a decade-plus later from the one that Reagan claimed to "remember" in 1980—as the voting bloc in whose "values" he would "[root] his political life" (181–82). For the present purposes, we may bracket the competing economic visions of Democrats and Republicans in this period. More important in our context, the period's politicians—on both sides of the aisle—have in common this quality: their electoral successes were directly tied to their ability to appeal to voters as middle-class. A majority of Americans were regarded by the political machinery and regarded themselves as middle-class, *even if* this constructed "class identity [. . .] [did] not correspond to objective class position" (Sosnaud, Brady, and Frenk 81). On the basis of this self-regard—this middle-class as-if-ness—a majority of Americans gravitated first rightward and then to the center. For related reasons, scores of American network television viewers responded so loyally to *Knots Landing* for its fourteen-year run.

In line with the political and economic movements charted here, *Knots Landing* did not hitch itself to a static conception of middle-classness. Over the course of its trajectory, the series chronicled instead the *changeable* fortunes of a self-identifying middle class, who first "enjoyed the fastest expansion in net worth during the Reagan boom" (Rubinstein 16) but then

"suffered in the economic dislocations" that worsened over the course of the 1980s, turning the boom into a bust (Ehrenreich 208). Stanley B. Greenberg writes powerfully about the feelings associated with this shift—and, in a glancing way, about the consequences for television:

> There was a growing sense in the country that the supply-side promise—the golden rule of mutual advantage—was a lie. The image of the entrepreneur—investor and wealth creator—was giving way to images of Michael Milken and junk bonds. Leveraged buyouts, mergers, and stock repurchases enriched shareholders but did little to fund investment. There was diminishing fascination with television shows like *Dallas*, *Dynasty*, and *Falcon Crest*, which seemed only to affirm the selfishness of the era's ethic. (146–47)

Knots Landing avoided this "diminishing" of "fascination" with its serial melodrama. The series had a capacity, quite different from that of *Dallas*, *Dynasty*, or *Falcon Crest*, to respond to the feelings of "middle-class suburban dwellers in the 1980s" and early 1990s—and those who imagined themselves as aligned with these "dwellers"—as they "began to feel [more] economically insecure" (Gainsborough 22). In David Jacobs's words, the series "was able to show what the economy was like" by making "everybody richer" as "the country was getting richer in the [early] [19]80s." In turn, the series could *keep* "showing what the economy was like" in the late 1980s and early 1990s by focusing attention instead on the financial fragility or losses of characters like Harold Dyer (Paul Carafotes), Linda Fairgate (Lar Park Lincoln), Anne Matheson (Michelle Phillips), and—most especially—Olivia Cunningham (quoted in Jacobs 2003). The first time I encountered it, I was somewhat baffled by Jacobs's retrospective assessment about often-peripheral Olivia: "Olivia,

oh man! She had the greatest arc of all, [. . .] I think" (quoted in Jacobs 2006). But locating that comment in a context like the present one may help to account for its genuine explanatory currency. First whisked by her mother from the cul-de-sac to a series of more lavish residences, then left as a young adult to face episodes of unemployment and to struggle in making rent on a shabby apartment, Olivia's "great arc" has power because it traces the middle-class *fear of falling*. Barbara Ehrenreich documents this fear of falling in a book of the same title:

> The "capital" belonging to the middle class is far more evanescent than wealth, and must be renewed in each individual through fresh effort and commitment. In this class, no one escapes the requirements of self-discipline and self-directed labor; they are visited, in each generation, upon the young as they were upon the parents.
>
> If this is an elite, then, it is an insecure and deeply anxious one. It is afraid, like any class below the most securely wealthy, of misfortunes that might lead to a downward slide. But in the middle class there is another anxiety: a fear of inner weakness, of growing soft, of failing to strive, of losing discipline and will. Even the affluence that is so often the goal of all this striving becomes a threat, for it holds out the possibility of hedonism and self-indulgence. Whether the middle class looks down toward the realm of less, or up toward the realm of more, there is the fear, always, of falling. (15)

Just so, Olivia. We not only watch her confront "a downward slide." Through the fearful eyes of former stepfather Gary, we also watch her threaten to "los[e] discipline and will" when she lies (and he can tell) to finesse money out of him. Along

with Gary, viewers are invited to beam over Olivia's final, modest "effort and commitment." She returns to him an un-cashed check, and the character departs from the series with "[t]he 'capital'" of her integrity intact, "self-directed" toward a new life in Miami in a thoroughly middle-class movement.

Coda: Other Landings

Well beyond the early 1990s, middle-class appeals have had a remarkable, ongoing ability to take the temperature of the American public. Consider these various moments in recent political history: "Clinton and Dole's courting of the 'suburban mom' vote" in 1996 (Gainsborough 77); "the systematic message of the [2004] Kerry campaign [. . .] revolv[ing] not around the poor but 'working families' and the middle class" (Press 18–19); and, most contemporary, Obama's 2012 championship of the needs and priorities of a "broad middle class, the trump card of the electorate" (Patterson 2012). The staying power of such addresses helps to explain how and why *Knots Landing* incited one last effect that we could call a "middle-class movement." Later dramatic experimenters making "quality" primetime television have followed *Knots Landing*'s cues and have moved, likewise, to find meaning and value in middle-class subjects. Two series are most readily identifiable in this genealogy: *Six Feet Under*, which creator Alan Ball describes as "*Knots Landing* set in a funeral home" (quoted in Peyser 52); and *Desperate Housewives*, whose Wisteria Lane evokes Seaview Circle so strongly that Warner Brothers marketed the DVD box-set release of the first season of *Knots Landing* with the tagline, "The original *Desperate Housewives*." (The association becomes all the more available because of the appearances of actors Marcia Cross and Nicollette Sheridan in both series.) Of course, *Knots Landing* may be profitably understood not just alongside quality programming of the early 2000s but also alongside the quality programming made at the time of its own network run—the topic of chapter 3.

Extending the Discourse of Quality

Whose "Quality"?

"Extending the discourse of quality" means, in part, entering an ongoing critical conversation. In that conversation, the term *quality television* has been powerfully identified as a vexed one whose changing contexts are important. Discussing the earliest of those contexts and attending to the abundant programming produced for American network television by MTM Enterprises, Kirsten Marthe Lentz reminds us that *quality television* is a term with origins in the television industry itself. Those origins need to be remembered as the term is reused in criticism. As Lentz explains, "During the 1970s the television industry adopted" new terminology for describing the "renovated shows" made by MTM. "Appeals to 'quality television' promised to improve the television text aesthetically" (46). These appeals to "quality" were not neutral. They took up taste categories that were historically situated and industrially determined. As a consequence, any reactivation of the term *quality television* to discuss American television programming, past or

present, ought to acknowledge the term's relationship to television's industrial history. Moreover, that history's American scene is just one site where the idea of "quality" television was developed and spread. The 1970s American use of the term *quality* designates formal achievement, the elevation of television's artistic sophistication. For a contrasting use of the term, we could look to western European and British television contexts in the same decade: a period of massive deregulation of those nations' television industries. At those other sites, *quality* was differently associated with programming that continued to "embrac[e] the public service remit," despite deregulation (Elsaesser, "Quality" 15). In the process, "quality" programming transformed that remit. It moved away from any lingering, snobbish association with the idea of "uplift[ing]" audiences (Creeber 24). At the same time, this "quality" programming moved toward other, overlapping goals: "match[ing] the diversity of a plural society, [. . .] providing usable stories," and maintaining "an ethic of truth-telling" (Nowell-Smith 39; see also Hachmeister 27).

This picture of what the term *quality* has meant, could mean, or should mean gets even more complicated when we fast-forward, as it were, from the 1970s to the 1990s and beyond. For instance, in the United Kingdom in the early 1990s, new television marketing strategies were associated with further industrial upheavals. Writing in that context, Geoffrey Nowell-Smith rejects both the American association of *quality* with aesthetics and the British association of *quality* with service. In his view, neither approach is adequate to the increasingly chilling economics of "quality." As a result, quality itself may have to be described and interpreted in the likewise chilling language of calculation: "What does quality mean in this context, or set of contexts?" he asks. "It is clearly not an absolute [. . .]. Quality is something you can have more or less of, but the ultimate measure of it is customer satisfaction. It is a marketing objective to which certain industrial procedures are applied, and it can be made to produce profit" (37). Along similar lines yet in

a different context, Dana Polan trains his eye on "marketing objective[s]" at American premium cable television networks at the turn of the millennium. In so doing, he asserts that "the very notion of quality needs to be updated in order to better address new and complex ambitions of popular television today" (97). To accomplish that "updat[ing]," he explores in detail how a network like HBO, "[f]reed, as a subscriber cable service, from the FCC constraints around obscenity and not caught up in PBS's public service mandate," can experiment with programming. Such programming retools "quality" as it also *exploits* the "multiple connotations of 'mature': challenging, serious, but also sexually daring and promising entry into illicit worlds" (175). And for Polan, the rendering of "quality" as "maturity" is, indeed, a form of exploitation. HBO capitalizes on its unique position in the television marketplace, however superficially the network may disavow the value of that market position:

> HBO may try to offer its products as alternatives to the supposed crassness of commercially sponsored network television—as in its slogan "It's not TV, it's HBO"—and insist on their cultural distinction from the marketplace, but that very insistence is a way of marketing its products as special and specially desirable. [. . .] [A] premium cable channel like HBO relies directly on subscriber fees, [. . .] [so] [i]t may even be the case that for all its talk of quality and distinction, HBO is potentially more reliant on sheer numbers of spectators than the networks, for whom demographic factors become as important as quantity. (175–76)

These are keen efforts to contextualize and complicate the thorny idea of "quality" in historical, geographical, and economic ways. Alongside them, many other admirable

65

efforts could be cited (Feuer, Kerr, and Vahimagi; Moseley; Geraghty, "Aesthetics"). Yet despite this work, an intractable use of *quality* to mean something like "good" programming on an MTM and/or HBO model persists in certain journalistic and scholarly literatures on television, especially but not only American television (see for instance Caldwell 26–27 and Sepinwall 8–9). More important in the present context, such assertions about "quality" programming also participate in a persistent differentiation of "good" television from the various types of programming denigrated as "soap opera." That latter persistence may be surprising, given the thoughtful work done, for instance, by Robert Thompson and others following his lead to demonstrate how the 1980s' "quality dramas were rooted in the soap opera," how the success of primetime series like *Dallas* (and, we may infer by extension, *Knots Landing*) paved the way for the development of quality seriality in lauded programs like *Hill Street Blues*, and how *Dallas*'s own innovations depended in the first place upon borrowings and adaptations of elements in daytime serials (Thompson 35). More specifically, the innovations depended upon hybridity: the conventions of daytime serials (which trade on continuous, non-episodic narratives, sprawling casts, and seeming melodramatic polarizations of good and evil complicated by moral ambiguity) were fused with those of primetime series (which air once a week, have hiatuses between clearly demarcated seasons unlike British primetime serials, and enjoy bigger budgets and higher production values than daytime serials).

Less surprising than inattention to daytime serials in some journalistic or scholarly conversation is the fact that the makers of lauded 1980s programs *themselves* did not explicitly acknowledge their indebtedness to these serials. In one of her several nuanced discussions of quality television, Jane Feuer underlines how such series angling for the "quality" designation aimed to "erase" this "debt":

> When [American] quality TV looks to its roots in se-
> rial form, it tends to invoke the serial tradition of the
> British "classic serial" imports popular on PBS [. . .].
> However, there is another, native serial tradition to
> which the prime-time quality serial of the 1980s is
> even more indebted: the tradition of daytime con-
> tinuing drama or soap opera. Not surprisingly, this
> is a debt that the creators of these shows would
> rather erase. (111)

Why the anxiety about "soap opera"? In no small part, mi-
sogyny and sexism play key roles in the efforts to distinguish
"quality" fare from daytime serials and their "soapy" primetime
followers. As far back as the radio development of daytime
serials that would migrate to early television, the makers of
such serials, their sponsoring advertisers, and many members
of their audiences understood the work as programming for
women. Consequently, the serials deployed "feminine" appeals
and forms of address that are supposed to be particularly attrac-
tive to women, including attention to domestic arrangements,
to interpersonal relationships (especially romantic and marital
ones), and to focally showcased women characters meant to
provide points of contact and identification for listeners and
viewers who were likewise women.

A version of this gendering of genre was unapologetically
embraced in *Dallas* and *Knots Landing*, as well as in popular
responses to the series. As discussions in previous chapters of
this book have already indicated, the lives and loves of best
friends Karen and Val were at the core of *Knots Landing*, and
the actors who played them, Michele Lee and Joan Van Ark,
were figured routinely in press coverage of the series as giv-
ing *Knots Landing* its heart and soul. Indeed, segments on talk
shows, articles in periodicals like *TV Guide* and *Soap Opera Di-
gest*, and copy for trade publications devoted much more time
and space to Lee and Van Ark (and, to a lesser extent, Donna

Mills) than to any of the other actors in the series, including popular male leads like Kevin Dobson and William Devane. In turn, and in an amplification of this effect, the actors themselves responded to these cues and helped to shape the sense of Karen and Val's privileged, pivotal centrality to *Knots Landing's* fictional lifeworld. And the actors still play along, now with retrospection and in the interest of nostalgic mythologizing. For instance, it is almost impossible to alight on an interview, older or newer, in which Van Ark does not remind her audiences of *TV Guide* coverage that described Lee, herself, and Mills as *Knots Landing's* respective earth, wind, and fire (Van Ark 2003). So powerful is the shared sense of these women's priority to the series that it is metaphorized, over and over, as *elemental*. As for the series itself, it may not have given much more screen time to Lee and Van Ark than to other actors, but it nonetheless emphasized Karen's ethical compass and determined will, on the one hand, and Val's passion and its frequent entailment of fragility, on the other, in order to galvanize viewers' special investments in these characters. (In establishing such differing characterizations, *Knots Landing* is not unlike a contemporaneous CBS series, *Cagney and Lacey* [1981–88], in which, as Julie D'Acci details thoughtfully, "[v]arious conceptions of femininity were set into play" [21]).

While viewers did indeed respond favorably to the series' gendered appeals—as attested, for instance, in interview comments recorded for a television special, *Knots Landing Reunion: Together Again* (CBS, 2005)—some critics were less won over. (Think back to that *Variety* review that credits *Knots Landing's* pilot with indulging in the same "bad taste" that characterizes *Dallas*. Arguably, "bad taste" is a euphemism or alibi for a "feminine" orientation in the series.) Happily, the state of criticism has changed and continues to change in its challenges to such gender bias. For every contemporary journalist or scholar who continues to see "quality" only where there is no overwhelmingly obvious trace of "soap opera"—and thus where there is

a strong whiff of masculinity or even machismo, a rejection of "feminization" (Newman and Levine 82–98)—there is another who champions programs like *The Fall* (BBC Two, 2013–), *Orange Is the New Black* (Netflix, 2013–), *Orphan Black* (BBC America, 2013–), and *Scandal* (ABC, 2012–) (Benson-Allott; Geraghty, "Re-Appraising"; Kelly; Lyons; Paskin; Ryan). These programs, for which *Knots Landing* provides one major precedent among others, do not conceal their traffic with "soap opera" norms and conventions, they foreground complex stories about women, and they are often created and helmed by women who wield more power than, say, the female staff writers (nonetheless crucial players) who worked on *Knots Landing* in the early 1980s. Just as important, critics responding with admiration and praise to the more recent series are also reclaiming the word *quality* to describe aspects of the series that they applaud: yet one more evolution in the ongoing, complicated discourse of "quality" outlined above. Enlivened by such developments, often overtly feminist in their tenor, I wish to extend this new, renovated discourse of quality *back* to *Knots Landing*, at least in part because of the precedent and model *Knots* provides for the *Scandal*s and *Orphan Black*s of our own moment. To be clear about the chronology involved here, this current effort in extending the discourse of quality further (and backward) is not to be confused with what was said and written about *Knots Landing* at the time of its initial airing; then, the industrial, quality discourse of the day did not encompass the series but was used instead to market rival series like *Hill Street Blues*. Rather, I join the ranks of those generating a twenty-first-century quality discourse in order to perform a revisionist history and to give *Knots Landing* a different kind of attention than it has yet received. More specifically, this attention will be paid to some fine formal features of *Knots Landing* that often work in the service of its gendered appeals but that are not reducible or equivalent to the gendering of the series. Indeed, when this putatively non-"quality" series makes sophisticated, ambitious,

or otherwise "high" gestures, it draws nearer than has been remarked to the privileged sphere of (more typically masculine) "quality" programming as it was defined in the 1980s.

What Precedents?

That other programming often insisted on its place in a *cinematic* genealogy and trumpeted its efforts to import cinematic devices and techniques to the small screen. For instance, as Thomas Zynda notes in a landmark essay on *Hill Street Blues*, one of the most distinctive and noteworthy features of that series was indeed its ambition to adapt a cinematic style for network television (101). Like such series, *Knots Landing* has some vividly avowed cinematic precedents—as well as some less emphatically avowed ones.

On a number of occasions, David Jacobs has cited auteur Ingmar Bergman's *Scenes from a Marriage* as the key inspiration for *Knots Landing*. Jacobs originally conceived *Knots* as an American version or equivalent of *Scenes*, one that would likewise explore the vicissitudes of married life. Initially broadcast in six installments on Swedish television, *Scenes* came to the United States both in a televised form on PBS and in a reedited feature form for cinematic exhibition (1974). The latter, cinematic incarnation shored up *Scenes*'s association with prior, more experimental entries in Bergman's oeuvre and, more generally, its association with "art-house" ambition. (To understand this association, we may look back to Jane Feuer's writing on 1980s television. She invokes Bergman's miniseries as one whose "title [. . .] might have applied equally well to *thirtysomething*," and she yokes this claim to her assertion that *thirtysomething* [ABC, 1987–91] borrowed its "quick wit" from the "Woody Allen movies [that] captured the feel of Manhattan early yuppie culture" [85]. This two-part move testifies to *Scenes*'s potential ability to bestow not just credibility but a specifically *cinematic* credibility on "quality" programming like *thirtysomething*.)

Yet *Scenes* as model for *Knots Landing* only tells the more respectable half of a story about its development. Jacobs has left his collaborator, Lorimar executive Michael Filerman, to supply the other half of that story:

> I wanted to be more commercial. [. . .] And [Jacobs] was a little more arty, 'cause when he brought in the idea, it was to do, like, Ingmar Bergman's, you know, *Scenes from a Marriage*. [. . .] A[n American] television version of that. And I was looking more for an old Fox movie [. . .] called *No Down Payment* [. . .] with Joanne Woodward and Barbara Rush and Jeffrey Hunter and Cameron Mitchell and Pat Hingle. [. . .] So it was with a lot of young—hello?— contract players. This was in the, you know, the late fifties. They were guys who, you know, just got out of the army and this was a housing project on a cul-de-sac. [. . .] And I said, "Why don't you look at that and write something more like that?" So art became trash. [. . .] David was the good cop, and I reveled in my role as the bad cop. (quoted in Filerman 2006)

The consonances between *No Down Payment* (1957) and *Knots Landing* are indeed striking. The film's primary setting in one street of a postwar, southern California housing development resembles strongly the 1970s suburban cul-de-sac of the television series. In addition, we could use exactly the same language to describe both the four main couples whose lives the film follows and the four couples who first populate Seaview Circle: two newlyweds who have tense disagreements over the husband's work; a couple whose marriage is jeopardized by the husband's volatile temper and infidelity; one whose marriage is similarly threatened by the husband's alcoholism and by his refusal to recognize the gap between his ambitions and his talents; and the much more stable couple who adopt social causes

and who dispense counsel and comfort to their troubled neighbors. Filerman's word, "trash," may or may not be the best one to describe the qualities of *Knots Landing* that draw it near in scope and feel to *No Down Payment*. Likewise, the idea of "art" may or may not best help us to understand Jacobs's ambition. With or without these terms, we can see that the series is a hybrid. It borrows *Scenes*'s emphases on complex conversation and on accretive shifts in feeling and mood; it also borrows *No Down Payment*'s action-packed, hothouse plotting. What matters about *art* and *trash* is that they provide a shorthand that Filerman can use to make himself easily understood to a number of different interlocutors. In the interview quoted here, he speaks with various fans who contribute to a website devoted to *Knots Landing*'s history. And both he and those fans are comfortably conversant in the language of "quality," with its emphases on artistry, that originates in the 1970s American television industry and that moves outward from the industry—to seem everywhere "in the air."

What's more, other notions from the "quality" discourse are just as powerfully in the air. Jacobs, for instance, was reluctant to green-light a storyline about the stealing of Val's babies (Filerman's idea) because of how "vulgar" he thought its exaggerated, "soapy" contours would be (quoted in Jacobs 2006). And yet soapy "vulgar[ity]" produced a significant level of popular success and appeal. *Knots Landing* garnered its highest-ever ratings for the cliffhanger episode in which Val gets the first glimpse of her twins since their abduction. Moreover, the larger narrative of which that episode is a key part did not just appeal to viewers but constitutes a striking version of the gendered construction of *Knots*'s appeals, described above. That larger narrative includes a memorable anatomization of Val's dissociation of identity after the loss of her twin children (Salvato 104–5). The dissociation not only gives piquant form to the melancholia that displaces and refuses mourning, but also yokes *Knots Landing* powerfully to the daytime serial genre. That genre has

long featured representations of "multiple personality disorder" (as dissociative identity disorder was formerly called) as a staple narrative feature and did so with particular vividness in the 1980s in such programs as *One Life to Live* (ABC, 1968–2012) and *Santa Barbara* (NBC, 1984–93). Like those contemporaneous serials, *Knots* "feminizes" such elements of storytelling as children's abduction and dissociative identity by linking them to explorations of concepts and issues framed as "womanly": in this case, maternal intuition (only Val believes—"knows"—that her babies are alive during a period in which everyone else takes them for dead), daughterly angst and deprivation (the aftermath of the kidnapping revives a buried animus that Val directs toward her own mother), and cathartic talk (Val's expression of complex, ambivalent feeling is associated with womanhood when it emerges most pointedly and poignantly in conversation with a therapist who is also a woman).

On such occasions as the foregrounding of this storyline, *Knots Landing*'s "unreputable" likeness to daytime serials and *No Down Payment* is supposed (by Jacobs, for instance) to be redeemed by its otherwise likeness to *Scenes from a Marriage*, which is imagined as lending it respectability and tipping it more toward "quality." Yet *Scenes*'s *own* relationship to "art" and "trash" is quite complicated. Members of the television industry and scholars of television studies tend to see *Scenes from a Marriage* as an exquisitely shot, thoughtfully written, and brilliantly acted miniseries that works well both on the small screen and in movie theatres. (I count myself among this number.) By contrast, critics and scholars of cinema tend rather to dislike its populist mode of address, its melodramatic representation of emotion, and its serial narrative elements. In their evaluation, *Scenes* abandons the daring that characterizes earlier, more fully experimental (and therefore "better") work by Bergman. Thus Teena Webb complains of the ways in which Bergman "tap[s] into a kind of soap opera approach" in *Scenes*; she imagines with dripping irony (and condescension) "the lofty level of the

viewers" who "watched the series" in Sweden, where "the streets were supposedly empty during the hours it was shown, and the Swedish equivalent of the Rose Bowl was cancelled rather than displace it" (1). In a similar vein, Lester J. Keyser consults Bergman to discredit *Scenes*:

> Bergman was acutely aware of the restraints televi-sion had imposed and warns in his preface to the [published version of the] teleplay that artistically sensitive people will be aesthetically sick after the very first scene because *Scenes from a Marriage* is so readily understandable. Apparently, simplicity and straightforwardness were two concessions he gladly made to capture a large audience. Considered in bare outline, even the plot he constructs in *Scenes from a Marriage* seems quite akin to hackneyed soap opera. (316)

Keyser softens his critique and nuances his perspective on *Scenes* as he proceeds to applaud its refusal of sentimentality (317). Yet he and Webb nonetheless share criteria for aesthetic appreciation, rooted in skepticism. They have a similar suspi-cion of mainstream accessibility, a suspicion of relative straight-forwardness, and, most especially, a suspicion of any borrow-ing from or resemblance to "soap opera." Instead, they prize the cultivation of difficulty, the risk of obscurity, and the rejec-tion of popular formulae. This version of aesthetic apprecia-tion does not make much room to value what Bergman strove aggressively to accomplish with *Scenes* (and other efforts): to get "ordinary folks [to] make themselves a sandwich and sit together and have a chat in the kitchen" after viewing the work (quoted in Bjorkman et al. 130; requoted in Keyser 314). More-over, accomplishing that goal meant, in the case of *Scenes*, also aggressively *depicting* the daily rhythms and shapes of eating, conversation, and domestic inhabitation. By representing these

quotidian activities, Bergman values them. He also reveals his respect for lived time as social time, which Elsaesser (quoted earlier) takes to be among the key achievements of worthwhile television. Likewise, I take such respect for lived time as social time to distinguish *Knots Landing*. Inevitably, some assessors of "quality" will be guided by other measures of achievement. More important, some of these assessors could *also*, possibly see in *Knots Landing* qualities to hail as "quality." Such qualities mark special episodes of the series, whose formal ambitions are more heightened than in its contrasting, routine installments. (Yet, as we shall see, even some routine qualities of *Knots Landing* are arguably definable as "quality," too.)

"Quality" Everywhere

Knots Landing's two-part "Noises Everywhere" (episodes ten and eleven in season nine) are just such "special episodes" as I name above. They are "special" because they mark the 200th and 201st installments of the series, a milestone that the makers of *Knots Landing* wished to mark with exceptional form and content. They are special, as a consequence, for their representation of Laura's death and funeral, as well as for the style used to render this representation. Yet they are also special for the approach taken to develop the episodes' form and content. That approach was singular enough to warrant feature article coverage in *TV Guide*; the article offers a detailed account of the development approach in question:

> The house [just a ridge below the historic Hollywood sign] [. . .] belongs to *Knots Landing* executive producer David Jacobs, but [. . .] for [. . .] two days of [an] unusual exercise, the house belongs to William Devane's character, Greg Sumner. [. . .] What [the] actors will be doing is an improvisation that will be the basis for

the 200th and 201st episodes of *Knots Landing*. [. . .] A sound crew and four video cameras will record everything that occurs. Jacobs and executive script consultants Bernard Lechowick and Lynn Latham will then base the scripts on what the actors have done.

This is a risky undertaking. [. . .] But it is also a way for the actors, who often feel they know their characters better than the writers do, to have their say. [. . .]

But no new plot emerges. After two days and 16 hours of videotape, the actors depart for a seven-week break and it is up to Jacobs and the writers to turn what seems to have been a desultory exercise into two riveting scripts [. . .].

[And] like football coaches, when they [watch] the tapes, they [see] things they hadn't seen before. "We were initially disappointed that we didn't get any new plot," Jacobs admits, "but we got emotional development and that leads to story." What the actors offered were new feelings and new facets of their characters. [. . .] What was revealed in the improvisation is the me-and-my-shadow relationship that develops between actor and character on a long-running series. (Littwin 8–9)

In this instance, *Knots Landing* innovated "unusual" production practices. And, as we shall see, the practices yielded rich forms of characterization and address. Thus, what is truly special about a "special event" pair of episodes like "Noises Everywhere" is not just the centrality of departures (like Laura's) or reunions of characters (long-absent Richard

returns to *Knots Landing* for Laura's funeral). More special is the *process* of making episodes in an experimental manner and *marking* that experimentation in the matter of the episodes. As the *TV Guide* account intimates, this kind of experiment in collaboration is a logical development for the personnel of a long-running series. (Especially so in the case of *Knots Landing*, where even before this moment the actors, as discussed in chapter 1, had a higher degree of access to the writers than is the case in most series television.) Actors who have lived with—and, in a funny way, as—characters for years on end have a complex understanding of and relationship to their roles. Indeed, they often have better memories of those roles than a rotating cadre of writers. Such a complex relationship can allow the actors, on the one hand, to propose choices that are consistent with seasons' worth of characterizations, and, on the other hand, to propose choices that test the limits of those established characterizations.

This duality offers a boon to faithful audiences, who expect beloved characters to be consistently recognizable but also to evolve and reveal new dimensions. In episodes like "Noises Everywhere," a key pleasure, if the viewer is prepared or inclined to experience it, comes from subtle texturing and re-texturing of relationships rather than from exciting plot developments. Moreover, this re-texturing of relationships might be understood as a species or dimension of quality. In "Noises Everywhere," one notable example of such quality consists in an intricately written conversation between Mack and Karen. Mack's grief and perplexity takes the form of acting out drunkenly; in the process, he urges Karen, always ready with the "right" answer to any question, to "take time to think." The request is met with a pause, in which Mack adds that he "feels [Karen] thinking" because he is "thinking about [her]." This complex language is designed to cue a viewer response parallel to Karen's. The scene asks us, too, to "take time to

think": about what might be subtly askew in Mack and Karen's otherwise happy dynamic; about whether she is indeed a know-it-all; about whether she could or is likely to tweak her behavior. (Indeed, she does in a subsequent scene with Richard: she shares "a private joke" that he doesn't get, but we of course do, as he solicits her opinion more than once and she tells him she'll "have to think about it.") Jacobs may lament to his *TV Guide* interviewer that the sessions at his house didn't yield "any new plot." Yet as he hastens to add, the "emotional development" that emerged from the sessions is far more valuable. This assessment of value jibes with his comment on another occasion, when he declares that the "greatest" moments in *Knots Landing* "were never about the plot" but about the nuances of relationships (quoted in "Museum").

I suggested above that writers Latham and Lechowick, working closely with Jacobs, found a way to mark the manner of their experimentation in the matter of "Noises Everywhere." This reflexive part of "Noises" pivots on the attention called to videotape within the second episode: that attention echoes the way in which video recordings of the actors, later mined for material, were used during the brainstorming weekend at Jacobs's house and afterward. In an earlier episode of *Knots Landing*, Laura, who is suffering from terminal cancer, has refused to spend her final days at home or to let Greg remain at her side in the Minnesota clinic where she has chosen instead to die. This startling decision is less startling than it otherwise might be because of its fidelity to Laura's ongoing characterization as prickly and iconoclastic. All the same, Deborah Esch suggests, "Laura's vexing decision dictates an apparent violation of the diegetic contract as well [as the social one], in that the viewer is deprived of the pivotal event of her death, which in ['Noises Everywhere'] is represented third-hand in her husband Greg Sumner's report of a phone call from the clinic" (87). In other words, *Knots Landing* condenses the violation of a social norm and the violation of a television norm. Prior to "Noises Everywhere,"

the same condensation is accomplished when Laura explains her decision to die alone both to Greg *and by extension* to *Knots Landing*'s audiences: "It's simple: I don't want to be watched." Yet Laura *is* willing to be watched on her own terms and after her death in a series of "farewell messages on videotape" that she makes for her friends, former husband Richard, current husband Greg, and one-year-old daughter Meg. Viewing Laura's videotape in the den of the Sumner mansion (and Greg's later bedroom viewing of Laura's message for him) become central to the second installment of "Noises Everywhere." As Esch describes them, Laura's speeches to the assembled viewers are the pre-recorded work of an absent person, greeted largely with muteness, laughter, and tears. For this reason, they become an allegory for how television in general works (90–94). Television as such is like the situation presented in the onscreen scenes of viewership. It is a medium in which words and images are recorded, the transmission of these recordings makes the absent actor present to viewers, and those viewers, for the most part, respond with non-verbal attention and perhaps amusement and sadness (though some, like Greg, also talk back to the screen).

In this way, "Noises Everywhere" turns on a double-hinged movement. The video footage screened within the episodes reflects the production process that preceded the shooting of those episodes. Yet the screening also reflects the *reception* process with which those episodes would be greeted upon airing. (*Knots Landing*'s audiences watch Laura's tape, too.) Moreover, the screening is depicted with audiovisual complexity: another marker of "quality." In "Noises Everywhere," the shot/reverse-shot structure, used to edit scenes of characters watching Laura's video messages, accomplishes quite different work from its more tried and true uses in television. On those more usual occasions, the camera cuts back and forth between two characters in close-up or medium close-up, and that camerawork enables the facility with which viewers "put themselves in the position

Laura's ghostly image appears on a screen within a screen (*top*) and then, with slight distortion mostly to her hair, as frozen by VCR's pausing (*bottom*).

of both [characters]. The appeal to 'multiple identification' means that viewers cannot simply identify with one character in order to judge and understand all the developments from that character's point of view" (Ang 75). "Noises Everywhere" does indeed feature shot/reverse shot scenes that work in this typical manner. For instance, as Gary and Val converse in the Sumner kitchen, they stand in similar positions by the sink. These positions give the characters material equivalence, as does the light that bathes them. (Gary is closer to a window through which light appears to stream, creating a partial shadow on the right side of his face. The casting of another shadow from Val's head onto the wall to her right is meant to mirror and match it.) And this material equivalence invites us to weigh the "equivalence" of the characters' emotional positions: he feels like a failure and resents her "polite" encouragement instead of truth-telling, she feels that it "isn't true" that he always fails—and we see not just shots and reverse shots but the plausibility of each perspective.

Yet the turn to tape viewing accomplishes something stylistically and tonally different. Replacing a more orthodox "viewing" of Laura's body with an engagement of her onscreen image, the tape viewing is propelled by shots of Laura and respective reverse shots of the other characters. But they are curious shots and reverse shots. For one thing, the camera lingers much longer on the bereaved characters than on Laura, and it draws intensely closer to them. The contrast of her relative composure with their emotional outbursts (Karen's raucous laughter, Val's sobbing) pulls our identification in multiple directions, to be sure, but much more to the various living than to the one newly dead character. (This effect is amplified when Laura asks Val to remember a pivotal conversation from the early episode "The Lie," discussed in chapter 1. As we are also asked to remember that episode, we are allied more closely with Val than with Laura, who is directing her and our reactions.) For another thing, an unusual *framing* of Laura reminds us that her recording belongs to a different moment in time and to a different

material order. Though some shots of Laura are direct, the first one, plus a greater number of subsequent ones, show us also the boxy television set on whose VCR the tape is playing, creating a screen-within-a-screen effect. As Greg pauses the tape, the final shot of Laura captures not only her face but also a slight distortion effect, "a few horizontal bars of white noise and slightly skewed picture" (Hilderbrand 13), entailed by pausing the VCR. Together, these effects convey the relative "remoteness" of Laura not just from remote control–wielding Greg but also from us. Thus we are invited to think of ourselves as *closer* to Greg and to the other living characters—in both senses of the word. They seem physically nearer because their images are differently mediated, less ghostly. They seem emotionally nearer as we are invited to do our own version of the strangely enlivening grieving that they perform. (Stony and stoic for most of "Noises Everywhere," Greg finally breaks down while watching the tape.)

While the audiovisual complexity that I describe here is not determined by *Knots Landing*'s gendered appeals, it nonetheless works in the service of those appeals. If I emphasize the roles of Karen and Val in the scene of videotape viewing, then that is because the scene itself emphasizes their importance. It also wryly and secondarily emphasizes the "non"-importance of Abby, a sometime rival of Laura to whom her joking, parting message is, "I have nothing to say." In fact, though, it is the yet more tertiary Gary and Mack to whom Laura has literally nothing to say: that is, no direct messages to them separate from the ones she puts to the women. One effect of this orchestration is to prioritize the women's relationships with each other and the feelings that those relationships conjure for and among the women. By contrast, the men are not only physically proximal to the women but, in their relative silence and non-expressiveness in this scene, also "appendages" to the women's more robust circulation of affect. Again, that affect may take differing forms that match the "[v]arious conceptions of femininity" that

D'Acci locates in 1980s narrative television. But whether we are hearing Karen's gut-driven guffaw or Val's unsuccessfully stifled cries, giving way to choked moans, what we hear is largely a women's matter, *that* women matter, and that their mattering is conditioned by their capacity for lively, emotional presence to the work of mourning's early stages.

This reading leads to very different conclusions from Esch's. She emphasizes what she takes to be the pervasive *deathliness* haunting the images of "Noises Everywhere": not only the images that Laura has prerecorded but also the images of the other characters' "real-time" viewing of Laura's tape.

> The televisual scene of mourning is already haunted by the revenant who takes up residence in the VCR. The ghost in this machine is not only conjured; she herself conjures, exercising her own remote control over her survivors from another time and place [through a] figure [of speech], [a] fiction of address, [a] reverse apostrophe from before and beyond the grave. [. . .] [T]he apostrophe from the dead does not afford consolation to the living [. . .]. In rhetorical terms, what confers the power of speech on the absent, the dead—the figure of prosopopoeia—seems symmetrically to allow for the survivors' being struck dumb, frozen in a freeze-frame that may be understood to prefigure their own deaths. [. . .] It is as if Laura says not "you'll survive" or even "you survive" but "you are dead," "it's *your* funeral, for it is you who have (much to answer for and) nothing to say." (Esch 89–90)

I appreciate the smartness that Esch attributes to *Knots Landing*, on which she thereby confers a kind of "quality." (She says that *Knots Landing* itself, not just her reading of it, demonstrates something important about television's "conditions

of possibility and impossibility" [86].) Nonetheless, I do not see "Noises Everywhere" violating television's much-discussed "liveness" effects and replacing them with "deadness" effects. Rather, the interplay between videotaped Laura and Laura's survivors works instead to show us how liveness generally works. Indeed, that interplay shows us the *substance* of liveness: liveness simulates the live; it conjures the aura of the live. Laura has less of that aura, and its loss in her imaging may direct our attention in two, paradoxical ways. On the one hand, we may comprehend that liveness is a fiction: the other characters, like Laura, are not actually co-present with us in time, a fact of which her video may remind us. On the other hand, we may simultaneously experience *the real feeling* that fictional liveness nonetheless impresses on us: the other characters, unlike Laura

and by the contrast with her that the episode establishes, possess a greater semblance of the live. Contradicting her remarks about death and deathliness, Esch makes a claim somewhat like this one later in her essay. There she writes of "Noises Everywhere" that it "demystifies even as it exploits" liveness "in both its aspects": liveness encourages viewers to experience "the image [as] direct" and as "direct for [a singular] me" (94). In turn, I would make an alternative argument about both liveness and "Noises Everywhere." Liveness does not tell us that images are direct and direct for each "me." Rather, it calls on *us*, plural, to play along with the fiction of directness. (Answering the call may require a willing suspension of disbelief, some mild cognitive dissonance, or a winking acknowledgment of playing along.) If we answer that call, we do so because "directness" produces *pleasures* for this plural, eminently social us. And we, just so plural and social, are mirrored in the plurality and sociality of the mourners in "Noises Everywhere." As I suggest above, their mourning is not just collective and varied but enlivening. For this reason, these complex episodes may also invite us to think further about the dance of liveness and liveliness in television production and reception.

To be sure, Esch's own lively prose testifies to such energized television reception. Yet in her literariness, she misses an opportunity to disclose something more historically grounded about the VCR that Laura manipulates and that the others use in her wake. As Patricia Zimmerman documents, the era in which these episodes of *Knots Landing* were produced was one marked by excitement about the mass production and distribution of VCR technology. The excitement was attached to the hope that this technology would usher in a new era of empowerment for the consumer and make of the consumer, rather, a producer. Yet with some important exceptions in the work of independent video artists, most VCR users tended to be guided by what Zimmerman calls a "familialist ideology" (122); they recorded home movies much more than other kinds of footage. And even this activity was far more rare than the primary use of VCR technology: to watch commercially produced material, in a market and advertising context in which "consumption was accented over production" (150). Just as much as it meditates on liveness, "Noises Everywhere" gestures to this history. Laura is singular—a singularity connoted by her death—and exceptional for making a video. Yet far from art, that video is a sort of home movie (albeit a weird one), and the rest of the characters use the VCR as viewers rather than as makers of recorded images. What's more, they are *belated* viewers of video footage that Laura made much earlier. In this way, the living characters in "Noises Everywhere" stand in for the many "time-shifting" viewers at home who used their VCRs not just to record series like *Knots Landing* but also to watch and re-watch them, thus freed from the dictates of the programming grid.

Laura is a time-shifter of a rather different sort. In Esch's compelling formulation, she is a character who aims to speak "from before and beyond the grave." She is also one who slithers out of the social contract, and thus shifts out of the social time, in which she is "supposed" to die among a community of loved ones rather than alone in a clinic. Repeated discussions

about Laura's decision to die alone, including various specula-
tions about her motivation, suffuse the two parts of "Noises
Everywhere." (They are, as it were, everywhere its noises.) "I
see no mystery," Karen says at one point: an assertion belied by
her puzzling over and struggling with the meaning of Laura's
choice. A viewer looking beyond this *Knots Landing* narrative
to the series' production history could, much more easily, "see
no mystery"—or rather find the solution to the "mystery" in
the series' production history. Confronted with major budget
cuts from CBS as they embarked on the ninth season of *Knots
Landing*, the series' executive producers had to terminate the
contracts of two high-salaried regulars to make ends meet.
They reluctantly chose Constance McCashin and Julie Harris
(who played Val's mother, Lillimae) for the chopping block, and

McCashin was targeted because of the exciting narrative and
character work that could be done through the documenting
of Laura's illness, her death, and its aftermath. Having made
this tough call, Jacobs and his collaborators were left with a
limited number of ninth-season episodes in which to employ
McCashin. Hence, Laura departs for a clinic six weeks before
her death, and a narrative is built to explain that early depar-
ture and to mine it for complex feeling. Jacobs has since been
frank about his disappointment over the mercenary economic
reasons for major personnel changes like this one at *Knots Land-
ing*: "If anything finally took its toll on *Knots Landing*, it was the
amputations of the great characters. There was never a charac-
ter on that show, especially from the original core [. . .], that we
wanted to lose" (quoted in "Museum"). To some extent, the in-
tense dialogue about how and why Laura leaves *Knots Landing*
as she does constitutes an oblique commentary on how and why
Constance McCashin leaves *Knots Landing* as she does. It also
provides a tacit forum for Jacobs to exorcise some guilt about
the essentially unwanted loss. Mack can say finally that Laura's
decision—read: the producers' decision—was "wrong" but that
he doesn't judge and must respect it. In this way, he telegraphs

apology and forgiveness in one fell swoop. (Alongside Mack's dialogue, we could take Laura's telling line, "I don't want to be watched," to mean rather, "I want to *keep* being watched," or perhaps, "I don't want to be watched getting fired.")

The "Perfect" Episode (and Others)

With some regularity, the "special events" of cliffhangers provide an occasion to establish the possibility that characters and thus actors may not return to a series. For example, when *Knots Landing*'s ninth season ends with what could be Jill Bennett (Teri Austin)'s successful murder of Val, the cliffhanger raises the question: Will Joan Van Ark return for the series' tenth season? And how and when (according to a logic of crime and punishment pretty airtight in such series) will irredeemable Jill, and with her Teri Austin, be dispatched from the program? That cliffhanger, "The Perfect Crime" (episode twenty-nine in season nine), is also an example of an exceptional episode that features quality elements. Indeed, they are the same "quality" elements that distinguish "Noises Everywhere": (1) atypical forms of characterization and address; (2) a corresponding, atypical audiovisual grammar to orchestrate these forms of characterization and address; and (3) savvy meditations on the medium-specific stakes, implications, and meanings of television as such.

The episode opens with establishing shots of the Golden Gate Bridge and a downtown San Francisco hotel, where Jill has been plotting "The Perfect Alibi" in the previous episode of that title. These images let us know that we have, as it were, entered another world. It is a world with different, Hitchcock-inspired tones and textures (the San Francisco setting alludes to *Vertigo* [1958]), which will suffuse the ensuing episode. Indeed, these tones and textures are ones that Jill literally carries back with her to Knots Landing as we chart her progress on plane, then foot, right through the front door of Val's house. There

she enters the kitchen and dons a pair of pink rubber gloves for the "dirty but necessary" task ahead: killing Val so that she will no longer pose a threat to Jill's relationship with boyfriend Gary and making the murder appear as a suicide. (The donning of rubber gloves suggests obliquely that gendered domestic chores constitute their own version of terror. More profound, the gesture suggests that not just the invading assailant but the inhabitants of such a home, who would more ordinarily use its kitchen tools, may also perpetrate terror. Thus they may be represented, at close remove, by an only slightly more "alien" other like Jill.) Another kind of "vertigo"—also nodding to Hitchcock—is rendered by the atypical, pronounced canting with which the camera frames gun-wielding Jill as she enters the door of Val's bedroom or stands next to Val's dresser. Likewise off-kilter and departing from *Knots Landing*'s standard style, a fairly close shot of the clock on that dresser places it to the left of the frame's center and lingers just enough longer than usual on the familiar object to produce an uncanny effect. Consider, alongside these devices, some other intriguing ones: (1) The room is lit with much higher-contrast lighting than typically used, producing noirish, chiaroscuro effects. (2) Intensely eerie music plays, differing from the motif used more routinely in the series to suggest a combination of danger and suspense. (3) Jill appears, again atypically, to look directly into the camera. (4) The camera cuts with noticeable rapidity between mostly medium close-ups of Val and Jill. The lengths of these shots make the two characters feel farther apart than they are. Then a destabilizing cut to a shot from another perspective jars us into recognition of just how small the room is and how close the gun is to Val's face. And (5), in a costuming choice coming closest to camp, Jill is "disguised" in wig and glasses. In short, what we see (and hear) is that the aesthetic order of this world has been quite vividly renovated. (The temporal order has also been renovated: "What do you care what time it is?" Jill asks when Val looks at the clock, which no longer measures social

A canted camera positions Jill off-kilter.

time but the weird time of sociality's unraveling. Likewise, the corresponding narrative order is renovated: this one long scene proceeds across the first commercial break and well into the next segment of the episode before ceding ground to other plots, which would in a normal episode emerge much sooner.)

Jill's disguise, along with the rest of these techniques, is rescued from self-parody because of the knowingness with which the techniques get used. In the first of a series of winking comments also conspicuous for their deadpan humor, Jill admits that her getup is "funny" and that the situation that she has created is, in its way, absurd. Yet more aggressively winking, a scene of neighbors Frank (Larry Riley) and Pat Williams (Lynne Moody), whom Val was supposed to join, shows them watching a suspenseful rental movie. Frank distracts Pat with

his suspicious comment that something "weird" is happening next door—and then popcorn-chugging Pat shushes him and declares, "I want to see this!" Positioned like the Williamses in front of flickering screens, we are invited by the cues of scenes like this one to acknowledge the elaborate artifices of "The Perfect Crime." Yet we are also invited to let that acknowledgement enhance rather than tamper with our investment in the episode's genuinely suspenseful plot, which we, like Pat, "want to see." More important, these winking nods and the suspense that they underline (rather than scare-quote) are not merely playful or fun. The episode establishes an appropriate context—familiar, yet at the same time *de*familiarized—in which to raise more profound questions about characterization, genre, and the gendering of genre. At the center, indeed the centerpiece, of the long scene featuring Val and Jill is Jill's "poor Val" speech. Jill repeats those two words relentlessly as she vents her impatience with Val's chronic, melodramatic, and "feminizing" victimization and, in her understanding, Val's "selfish and manipulative" use of her victim status to "get under people's skin"—especially Gary's. On the one hand, a thick irony pervades this speech, as Jill really and truly attempts to victimize

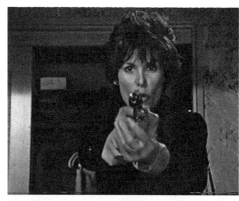

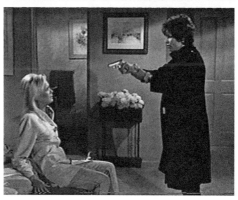

Jill stands closer to
Val than she at first
appears.

Val. On the other hand (call it the logic of just-because-she's-crazy-doesn't-mean-she's-wrong), Jill gives powerful voice to a feeling that many viewers may share even as they sympathize with Val. That feeling of impatience or irritation was certainly experienced by writers Latham and Lechowick, who crafted this storyline and the latter of whom wrote the script for this episode. When they joined the staff of *Knots Landing*, they "inherited" characters that they had to write well and earnestly, but they didn't always identify unquestioningly with the histories and values associated with those characters—especially in the case of Val, for instance (Latham and Lechowick 2004), whose ongoing representation tends proportionally to fictionalize the brutality that women face in the world rather than the strength with which they greet it. In "The Perfect Crime," the writers' response to these conditions is, in its own way, "perfect." They recalibrate a characterization. Through the recalibration, they question some of the premises and assumptions, especially the gendered ones, associated with the characterization. They signal to audiences their invitation to participate, too, in the performance of such questioning. Yet they do not, in the process, deny but rather leave available to those audiences the possibility for attachment to the character. This is a delicate balancing act, and its achievement ought arguably to earn the "quality" designation.

It certainly earned viewer appreciation, particularly in the form of the *Soap Opera Digest* awards voted on by that magazine's readership. Two such awards were conferred on Joan Van Ark and Teri Austin as "Outstanding Lead Actress" ("1989 *Soap Opera Digest* Award Winners" 2003) and "Outstanding Villain" ("1990 *Soap Opera Digest* Award Winners" 2003), respectively. The more prestigious Emmy Awards remained, however, almost entirely elusive. Indeed, the Emmys are almost always out of reach for any primetime series whose makers are comfortable, as *Knots Landing*'s were, with coverage of the series appearing in publications like *Soap Opera Digest* and, more broadly, with the

understanding of their series as belonging to the stigmatized genre of soap opera. Saluting in particular the high quality of photography and editing for the series, Jacobs argues that "every artisan that worked on this show [. . .] was really snubbed" by Emmy voters because of snobbery about the soap association. He notes, in the same breath, that many of the very editors, directors of photography, and other "artisans" whose work on *Knots Landing* was disregarded did indeed receive Emmys for their quite similar work on other television series (quoted in "Museum"). Jacobs's assessment of the real craft that went into making *Knots Landing* is telling for one reason in particular. The features of the series that he highlights are not just to be singled out in special episodes like "Noises Everywhere" and "The Perfect Crime" but are rather diffused across the hundreds of episodes of *Knots Landing*. And scholars likewise point to the ways in which routine, not just exceptional, elements of the series make a bid to be understood as quality elements. Casting a passing glance at *Knots Landing*, Ellen Seiter, for instance, looks at the cuts to black before commercial breaks. Because they "[last] several beats longer than in most programs," these cuts aim for a "'quality' [. . .] connotation" by "suggesting that the audience needs a moment to collect itself emotionally, to think over the scene before going on to the commercial" (40). In a similarly brief but revealing analysis, Jim Collins lingers over a putatively "throwaway" joke between two minor characters about their television viewing habits. According to Collins, the joke has this upshot: the "'irresponsible,' nonquality program informs us why viewers *really* like quality television—for the wardrobes and the sexiness of the stars involved, which, as the characters of *Knots Landing* know, constitute the *real* pleasure of the televisual text" (335). In turn, we could argue that the joke, confounding the distinction between quality and "nonquality," is itself positioned as performing "quality" work. To this list of quality features like jokes and cuts to black, we could add other repeated elements from the fabric of *Knots Landing*.

These elements include, among others, the stylish overhaul of the opening credit sequence for the series' ninth season and the painstaking verisimilitude with which interior sets are dressed (and meticulously re-dressed). The key takeaway is to appreciate the mobility, transitivity, variability, and indeed promiscuity of "quality" tropes and motifs. These quality items attach to or erupt in many different kinds of television programming, including the nonquality ones.

Coda: What "The Characters of Knots Landing Know"

What Collins doesn't mention in his account of *Knots Landing*'s joke is that it is just one of two conspicuous meta-televisual moments—television moments *about* television—in the episode in question, "The Last One Out" (episode twenty-four in season twelve). The other comes when Gary remarks to Val that their bad timing in attempting to remarry is "like a soap opera." This second moment does not point, like the joke, to the "wardrobes and the sexiness of the stars [. . .], which, as the characters of *Knots Landing* know, constitute the *real* pleasure of the televisual text." Rather, it celebrates the *equally* real pleasure of investing in open-ended, serial narratives that explore the vicissitudes of loving yet complicated relationships like Gary and Val's. The scene in which this conversation between Gary and Val appears is part of an episode whose milestone status as the series' 300th is marked by ending with their long-anticipated remarriage. Thus the scene could be read as a direct complement to and inheritor of the energies, sentiments, and ideas from the beach scene in "The Longest Night" discussed at the end of this book's Introduction. Where that scene was motored by tears giving way to giddy laughter and held out the promise of the characters' eventual (but strategically deferred) marital reunion, this scene foregrounds laughter melting into tears and begins the fulfillment of that promise: Val proposes elopement

"now—tonight" and Gary assents with the declaration, "I do love you." The upshot is that of course clothing and sex appeal are important to the pleasures that *Knots Landing* generates, but so too are the operations of time, memory, and love. These different facets of "the televisual text" don't compete with each other for status as "the *real*" stuff of television or cancel out each other's value. Instead, they work in complex concert with each other. In the next and final chapter, I explore just such concerted workings—in this case, of "trivial" hair, makeup, and music with "serious" fine acting and allusiveness to classic Hollywood cinema. In the process, I demonstrate how *Knots Landing* makes pleasurably plural meaning and also how it makes or remakes stars and stardom.

Stars in Their Eyes

The Thing about Stars

As argued in chapter 3, *Knots Landing* sometimes draws nearer than expected to its "quality" others and rivals in the programming schedule, like *Hill Street Blues* and *L.A. Law*. Its quality may come, for instance, from experimentation with its shooting model or from formal ambition. These unorthodox manipulations of the production apparatus and aspirations to audiovisual complexity (or both) have another quality complement: the noteworthy acting of certain series regulars (Alec Baldwin, Julie Harris) or semi-regulars (Halle Berry, Ava Gardner). Moreover, these especially noteworthy actors are ones whose stars were made—or revived—by their appearances in *Knots Landing*. (Indeed, Julie Harris is exceptional as one of only two actors Emmy-nominated for her work in the series.) Yet when we think about stardom, we also do well to consider featured players in *Knots Landing* less available for the celebration of virtuosic acting. Some of these actors also became stars—or aimed to augment their star statuses—on the basis of *Knots*'s popular

reception. Consider Lisa Hartman, for instance, who had established a recording career before taking on the roles of Ciji Dunne and Cathy Geary in *Knots Landing* and who sang weekly insets in the series in the mid-1980s. (These insets meant to capitalize on the ever-increasing popularity, while transforming the nature and purpose, of music videos as they could be experienced via outlets like MTV.) Having become a star, Hartman tapped into fans' adoration of her voice, her characters—and their hair—to fuel interest in her immediate post-*Knots* album, *'Til My Heart Stops* (1987). Similarly, Donna Mills cultivated an iconic faciality chiefly through the makeup that she—unusual for a television actor—applied herself to play "fox-eyed" Abby Fairgate. Then she leveraged the astonishingly high level of interest in her eyes to make the 1986 promotional video *The Eyes Have It* (a sly edit of which is still much watched on YouTube, in an ongoing camp appropriation and appreciation [heartnouveau 2010]). In these cases, *Knots Landing* provided a cross-media set of platforms in which stardom could unfold and extend its reaches. Thus an examination of the series reveals the profitability, dimensionality, and surprising significance of elements of television production sometimes marginalized, treated as trivial or tertiary, in studies of the medium. Notably, these elements include incidental song, hair, and makeup. And the late 1970s, extending into the 1980s, was an era in which capitalizing on such elements of television production was at a major peak, as seen for instance in the iconicity of Farrah Fawcett's feathered hair in *Charlie's Angels* (ABC, 1976–81) and the wildly successful and admired use of popular song and colorful wardrobe in *Miami Vice* (NBC, 1984–90).

In this context, it is perhaps not surprising that *Knots Landing* could make "stars" out of pop covers and eye shadow. Nor is it alone in making or remaking the star turns of charismatic performers like Baldwin and Harris. More remarkable, and one of its signatures, the series also created spaces in which bravura acting could comfortably, rather than awkwardly, *co-exist* with

bravura spectacle and sound. No matter that Lisa Hartman's silky voice, Alex Baldwin's subtle line readings, Julie Harris's stirring gestures, and Donna Mills's evocative eyes are of such different phenomenal and aesthetic orders: they align. Yet they do not align in consecutive or segregated scenes. They come together simultaneously—and in wonderful, paradoxically fruitful ways. (Indeed, those four performers often shared the stage, as it were, with one another because of the personal and professional relationships among the characters that they played. With a nod back to chapter 2's discussion of American politics in the 1980s, we might see in television station–owning Abby's cultivation of Joshua Rush [Alec Baldwin] as a popular televangelist a vivid representation of neoconservatives' strategic manipulation of their relationship with the Christian New Right.) This chapter, "Stars in Their Eyes," analyzes and celebrates the workings of these unexpectedly generative confluences. Indeed, the chapter title aims to signal as much in three ways. As *The Eyes Have It* has it, the star is, in fact, sometimes *in* the eye. At the same time, *Knots*'s producers routinely recognized and exploited reservoirs of talent otherwise misunderstood as "faded": Harris and Gardner were still stars in *their* eyes. And the series provided a fertile playing field for younger cast members whose performances intimated a celebrity not yet established—but soon to come—and already dreamt of by these would-be luminaries with stars in their eyes.

So we will work through the different kinds of stardom and different meanings of *star* configured in these overlapping cases. And this interpretive activity must be situated within cinema and media studies' rich history of conceiving stars and stardom. Relatively early entries in these critical studies turned pointedly away from television. It is a medium and industry that was not supposed to be able to generate stardom as cinema does but only to "produce personalities" (Gledhill, "Introduction" xiii; see also Ellis). By contrast, more recent work indicates the various ways in which television—older

99

4

and newer—"has created stars in abundance" (Fischer and
Landy 229). Indeed, some star-making ingredients, like the
"ordinary/extraordinary paradox," used to be understood as
belonging more exclusively to the province of cinema. But
now scholars note that these phenomena "prove to be at
the core of television stardom—as might be seen during the
1988–89 U.S. television season, when Roseanne Barr rose to
sudden celebrity: an 'ordinary' woman whose fame was ac-
companied by extraordinary tabloid 'scandals'" (Butler 302).
At the same time, these more recent efforts unite with prior,
groundbreaking investigations of stardom. They share a con-
tinued commitment to understanding the *charisma* that seems
so necessary to the manufacture of stardom (Dyer 30–31).
They also aim commonly to understand how stardom makes a
commodity or a fetish—in short, a kind of object—out of the
star (Gledhill, "Introduction" xv; Stacey 143). In the process,
the star's exaltation becomes also a strange form of abjection
(Alberoni 70).

We may profitably build on these insights, particularly regard-
ing what is object-like about stars. And to do so, we might explore
how "star studies" cross with "thing studies." Scholars working in
the latter camp tend to make a distinction between objects and
things (though some also consider what lurks ambiguously be-
yond the distinction between objects and things). These scholars
assert that things only become objects when the things are part of a
subject-object relation: when (typically human) subjects *use* things
as objects. Yet such materials—everyday tools, for instance—can
reassert that they are things "when they stop working for us." Usu-
ally taken for granted, the materials become strange and new to
us "when their flow within the circuits of production and distri-
bution, consumption and exhibition, has been arrested, however
momentarily" (Brown 4–5). Writing about these phenomena, Bill
Brown pushes further. He points to what is, ironically, even more
slippery and intangible about these "solid" things:

100

On the one hand, [. . .] the thing baldly encoun-
tered. On the other, [. . .] [y]ou could imagine
things, second, as what is excessive in objects, as
what exceeds their mere materialization as objects
or their mere utilization as objects—their force as
a sensuous presence or as a metaphysical presence,
the magic by which objects become values, fetishes,
idols, and totems. Temporalized as the before and
after of the object, thingness amounts to a latency
(the not yet formed or the not yet formable) and to
an excess (what remains physically or metaphysi-
cally irreducible to objects). But this temporality
obscures the all-at-onceness, the simultaneity, of the
object/thing dialectic and the fact that, all at once,
the thing seems to name the object just as it is even
as it names something else. (5)

Brown's argument is itself a slippery "thing," but we can
get hold of it by looking at some concrete stuff. Let's recall our
Knots Landing stars and their charisma or "it" factor (Roach 1).
What if the "it" factor belongs not vaguely to the star (Mills,
Hartman) but to a specific part of the star's toolkit: her eye, or
hair, or vocal track? Then perhaps the eye, hair, or voicing is
exactly the kind of complex thing that Brown describes. The
circulating images of the star may turn that starry subject into
an object for sale, a commodity. Yet at the same time, a related
process may occur. A special part of the star may elude objec-
tification to become a curious "thing." And, paradoxically, that
thing may be so elusive *even as* "it" (voice, hair, eye) plays a se-
ductive role in selling the star. In Brown's language, this special
thing is "what is excessive in [the object, . . .] what exceeds [its]
mere materialization as [object] or [its] mere utilization as [ob-
ject]." This thing—made-up eye, styled hair, vocal track—has
expressive "force as a sensuous presence" that is more than ma-
terial or useful. As a result, we may find in this thing "the magic

by which objects become values, fetishes, idols, and totems."
The magical thing, no longer simply the property or prop of the
star, turns into its own kind of star: an "intens[e] presence [. . .]
become ever more enigmatic" (Nancy 6).

Crackle and Pop

Intense presence can be just as disorienting as it is absorbing,
especially for the bearer of a magical "thing." Lisa Hartman,
for instance, describes getting her "hair cut for the role" of Ciji
Dunne in *Knots Landing* and becoming "a big deal" because
of the role. Yet she doesn't quite understand how much of
the "big deal" is yoked to her big hair. Rather, she expresses
bafflement at the investment (literal and otherwise) in her hair
made by "producers, directors, network executives, even fans.
'I know that they mean well, but [. . .] the questions. They are
just these weird things that they say, like, "You got your hair
cut." What am I supposed to say to that? "Uh, yeah, I did."
It's strange'" (Hartman, quoted in Leahy 13). Certainly a star
may find "strange" this kind "intrusion," to borrow another
word of Hartman's. Indeed, hyper-attention requires careful
management to which the star was a *stranger* before stardom.
But the fact that hair, in particular, brings a star like Hart-
man into special focus may seem less strange if we follow the
lead of "hair critics" like Margaret Powell and Joseph Roach.
They posit that the "Big Hair" of the eighteenth century (79)
helped to invent modern notions of celebrity in that period.
Indeed, so "modern" was the invention that later periods, also
celebrity-obsessed, are still dealing with the vivid legacies of
the eighteenth century. The 1980s would be one such key pe-
riod. And Powell and Roach consider what, as it were, unites
the different strands of celebrity hair, past and more recently
present. In so doing, they also look further backward to an
ancient belief, common to many cultures and religions: that
demons and gods inhabit the hair. This supernatural presence

in hair was held to make hair magical, the outward display of invisible powers. Powell and Roach claim in turn that if hair is "magic," at least some of the magic is not simply inherent but *performed*. On heightened occasions, and depending on the height of the hair, the performance may be highly theatrical:

> [H]air is a performance, one that happens at the boundary of self-expression and social identity, of creativity and conformity, and of production and consumption. Hair lends itself particularly well to self-fashioning performance because it is liminal, on the threshold, "betwixt and between," not only of nature and culture, but also of life and death. That is true for several reasons: first, because hair grows, but not the way living flesh does; second, because it may be cut and shaped, but in ways that flesh can't be (or at least not as easily); and third, because its changing characteristics mark the passages of the body through different stages of life, but not with the same degree of challenge to prosthetic manipulation or replacement that other organs present. Surveying any terrain, the eye of the beholder seeks out the highest feature as focal point for its gaze, marking all the head as a stage, and the features on it only players. More intimate than clothing and yet more reliably prearranged than countenance, hair represents a primary means of staking a claim to social space on the occasion of first impressions. (83)

In the terms established by Powell and Roach, Lisa Hartman's hair performs extremely well. It allows her to "stak[e] a claim" on "the eye[s] of [many] beholder[s]." Part of the explanation for the success of that performance is historical. There are era-specific ways in which Hartman's hair could be "cut and shaped," "reliably prearranged" in five distinct

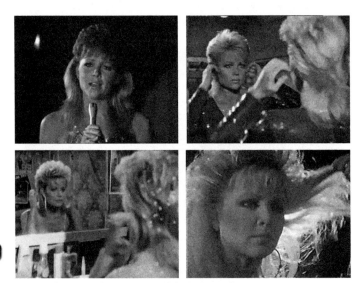

Lisa Hartman sports four distinct and distinctive mullets.

styles between 1983 and 1986: no less than four of them mullets and one (the shortest-lasting) a shag.

The 1960s-era innovations in the geometry of cutting hair were followed by '70s-era innovations in layering hair (Sherrow 165, 130). In turn, the work of the late 1970s and '80s was to synthesize further these two innovations, chiefly through playful experimentation with proportion, volume, and weight. In the process, ingenious stylists also exploited emergent technologies and the new methods, for instance, for perming and coloring hair that the technologies enabled. In its various permutations, the mullet was the perfect vehicle for this sort of experimentation: a capacity that its aesthetic appreciators call, tongue only half in cheek, "magnificent" (Larson and Hoskyns 37). Readers may be familiar with the slang term "hair acting" as a euphemism for bad acting—or, more precisely, the alibi that cosmetic enhancement provides for bad acting. And those

readers may question the tone of my own valuation here. But I find genuinely pleasurable and memorable (as did and do many audiences) the performances of Lisa Hartman's hair, especially her mullets. Consider, for instance, the installment-opening images of Hartman in "Celebration" (episode eighteen in season four). As she rides a bicycle down a Los Angeles street, the blowing wind animates her hair to connote pitch-perfectly the freshness and optimism of her character, Ciji. This is an instructive example of how hair may coordinate the vivid "first impressions" that Powell and Roach describe. Yet they also describe hair as potently "liminal, on the threshold [. . .] of life and death." Thus, how better to trace the poignant arc from life to death than through such liminal hair and its transformations? Ciji's hair is first animated dimensionally by the wind. Then, by contrast, we encounter the relative flatness of a background photograph of Ciji, hung on the wall behind a stage where she is supposed to perform (and is replaced by another singer). Through a dissolve, that foreboding still gives way to the image of wet, matted hair stuck to Ciji's head as her corpse washes up on the ocean's shore.

At the time of her murder, Ciji is a pop singer on the brink of fame, which will be achieved rather by Cathy Geary (the next character played by Hartman). Indeed, Cathy's appearances as a singer in husband Joshua's television program are so delightful that her popularity eclipses his. Like liminal hair that both is and is not of the lively body, the musical insets in which Hartman sings are both of and not of the narrative of *Knots Landing*. The songs do not advance the narrative, but they do not exactly "interrupt" it, either, as they develop powerfully the moods and feelings that the narrative conjures: Hartman's booming, poignant voice not only adds to the pleasure of the musical insets but also enhances their emotional texture, given the voice's powerful association with subjectivity and interiority. Indeed, the gravity of Hartman's voice matches and complements the levity of her hair. Hair and

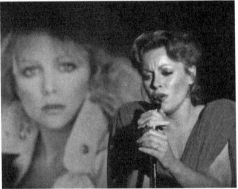

Wind gives way to
wave, life to death,
for Ciji.

voice, style and substance, surface and depth; these qualities interplay happily in Hartman's performances, and they thus demonstrate how opposites may harmonize rather than produce discord. A more complex harmonizing—yet a harmonizing, all the same—emerges in scenes that Hartman shares with Alec Baldwin as Joshua and Julie Harris as Lillimae, Joshua's mother and Cathy's mother-in-law. Hartman's hair and voice are finally more expressive than her face, while Baldwin and Harris, as we shall see, exhibit exquisitely subtle facial expression. Yet it is too easy to charge Hartman with comparative inferiority as an actor. She works hard and ably, and not just at singing and the swaying of head and hair that accompanies singing. Instead, what *Knots Landing* stirs up and stirs together may be better understood in terms borrowed from the study of musical theatre. In that genre, multifarious elements and many performers with different kinds of talents must come together. Scott McMillin, writing about musical theatre, conjectures that the genre's complex synthesis of elements and talents creates a particular thrill: the "crackle of difference."

> Great elation accompanies the run of a hit musical, and everyone involved knows the feeling. But that does not mean that the product of all this cooperation has been smoothed out into a unified work of art. When a musical is working well, I feel the crackle of difference, not the smoothness of unity, even when the numbers dovetail with the book. It takes things different from one another to be thought of as integrated in the first place, and I find that the musical depends more on the differences that make the close fit interesting than on the suppression of difference in a seamless whole. *Difference* can be felt between the book and the numbers, between the songs and dances, between dance and spoken dialogue—and these are the elements that

integration is supposed to have unified. Sometimes the elements *are* integrated, but I still feel the difference. (2–3)

Just so, *Knots Landing*. In the coda to the last chapter, I described the fabric of *Knots Landing* as highly "plural." Following McMillin, we can see how that plurality refuses "the suppression of difference." Rather, the series yields the special aesthetic pleasure that can be spun from the "crackle" of difference. Such difference is brought into relatively bold relief by the contrast between musical insets and the narrative scenes that precede and follow them. Yet it also pulses and ripples through many more scenes of *Knots Landing*. Lisa Hartman's charisma, as described above, also makes itself felt—and makes its crackling *difference* felt—in her scenes opposite Baldwin and Harris. At the same time, those scenes also merit attention for the memorable performances of the latter two actors.

The Eyes of Lorimar

As Barry King argues compellingly, special "ability in impersonation" is not a necessary ingredient for stardom (179). Yet at the same time, the relative possession or lack of this ability helps to distinguish some stars from each other (in King's classic Hollywood example, Bette Davis and Joan Crawford [178]). Not unlike Davis, Julie Harris is a star whose fame for stage and screen roles, particularly in the 1950s, is hitched precisely to an exceptional "ability in impersonation." In Harris's case, displaying this ability was also a matter of exemplifying the Method acting that dominated much postwar American entertainment (Gledhill, "Signs" 225). For the producers of *Knots Landing*, landing Harris for a role in the series was quite a coup, however faded her stardom might have seemed to some in the early 1980s. The casting was also a kind of serendipity: as David Jacobs recalls, Michael Filerman happened to run into Harris's

agent, Eddie Bondy, at the Los Angeles office of the William Morris Agency. In the course of that run-in, Bondy suggested that the *Knots* team might devise a role specifically for Harris. They were all too happy to oblige in the form of Lillimae, the mother who abandoned Val as a child and who comes to roost (and atone) in Seaview Circle (quoted in "Museum"). In Filerman's assessment, Harris "brought such class and such a dynamic to the show. I mean, this is the First Lady of the American Theatre, our Judi Dench" (quoted in Filerman 2006). Alec Baldwin brought a similar "dynamic" to the series in his first major role as Lillimae's son, Joshua—and, indeed, Baldwin and Harris's dynamic *together* makes milestones of so many of the scenes that they share. Those scenes also indicate the stardom for which Baldwin, in retrospect, can't help but seem destined.

109

Of the many scenes of this sort in which Harris and Baldwin play off each other, we might consider a paradigmatic one from the episode, "Until Parted by Death." That scene is also situated, more specifically, to teach us something about onscreen acting with eyes—and the tears that they produce. In the scene in question, Lillimae engages Joshua in a post-dinner conversation in Val's kitchen. She knows that he is coming unglued yet treads carefully in her suggestion that he look for the "help" that he may "need." (In part she fears inciting the anger that has been animating his volatile interactions with others, especially in his abuse of Cathy.) A medium close-up that positions Baldwin in the foreground and Harris in the background begins with a focus on him that emphasizes his downcast eyes. Baldwin has raised his eyebrows subtly but significantly enough to contribute to the doleful effect produced by casting eyes downward. Then the focus racks to Lillimae as she, who has also been looking downward, lifts her lids somewhat and with them her gaze. Anxious, she doesn't quite meet Joshua's eyes, and her lashes flicker slightly to connote that anxiety. As the scene progresses, Joshua, speaking in a very calm, even tone that

belies the content of the dialogue, indicts Lillimae for leaving him in his childhood with an abusive father. The tears that stream slowly down his cheeks amplify the effect of pathos combined with restraint. Similarly decorous—and for that, all the more potent—tears swell just a bit over Lillimae's lower lashes. She only gives way to fuller crying (though by comparison, say, with the full-throttle sobbing that Val routinely produces, still decorous) after Joshua has left the table and the scene. If viewers, in their turn, respond to this affecting scene with tears of their own, how might their crying be construed? In *Crying: The Natural & Cultural History of Tears*, Tom Lutz takes a rather dim view of melodrama. Yet he provides a critical perspective that is nonetheless useful to engage by way of beginning to answer this question:

> [I]n our everyday lives we constantly confront role failure, from the spectacular to the mundane, and rarely do we experience the kind of resolution [that] "impossible stories" offer. Melodrama's reputation as a low form comes from the improbability of its solutions. [. . .] But the [. . .] wish-fulfillment fantasies these [melodramas] purvey do not even pretend to be real-world solutions to the problems of meeting our culture's demands with respect to role performance. No one could mistake them for advice manuals. Most of our role-performance failures never get resolved—when we or our parents or partners are not good enough parents or partners, we live with the consequences, which often means no forgiveness, no restitution, no recompense. Melodramas exploit our desire for perfect resolution, and the tears we cry at these stories are a sign that we know such resolutions to be impossible. Our tears are proof, in fact, that we know very well how false melodramatic conclusions are. (266–67)

The scene between Joshua and Lillimae that I have described is both obviously melodramatic and concerned centrally with the question of "role failure." At the same time, it offers none of the "improbab[le] [. . .] solutions" to the characters' problems that Lutz characterizes as the "false [. . .] conclusions" of melodrama—and not just because of the scene's placement in an open-ended serial narrative. When Lillimae cries, some portion of that crying may be motivated by her guilt as a "not good enough parent." But in an ensuing scene with Cathy, Lillimae asserts that it is "too late" to help deeply culpable Joshua. Here, she clarifies that it is just as much *his* role failure as her own that she perceives in the prior scene. Registering that perception, her tears may convey to the attentive viewer something that Lutz supposes to be a "real-world" rather than melodramatic matter: the sadness entailed by the impasses in which there is "no forgiveness, no restitution, no recompense." Even if a viewer doesn't grasp as much consciously, crying in response to Lillimae's crying could be the body's way of documenting an intuitive recognition of this truth.

111

Of course, moving them subtly and yielding their tears are just two of many things that actors can do with their eyes. They can also paint them, as we are reminded with vividness by the elaborately—some would say *over*—made-up eyes of Donna Mills. (To return to Brown's terminology, her "excessive" use of eye shadow, eyeliner, and mascara is precisely what gives her starry eyes their "sensuous presence.") For her part, Mills, participating in and indeed becoming one of the leading lights of 1980s cosmetic indulgence, wouldn't characterize her making up as extreme. Or at least she didn't in *The Eyes Have It*, her self-produced video whose instructional value is explained by the copy on the back of its VHS slipcover:

> Donna Mills is one of the few actresses in Hollywood who actually applies her own makeup on the set and off. Now, you, too, can share in all of her beauty secrets in this easy-to-follow visual learning method.

The VHS slipcover for *The Eyes Have It* promotes Donna Mills's day-parted looks.

> Donna guides you through each of the steps nec-
> essary for a more perfect and beautiful you. Each
> segment is designed to show you the best way to
> apply makeup for daytime, worktime or playtime.

Mills's video measures the different parts of the day and
night and the different makeup needs that she takes them to
require. In this way, the video produces something closer to
the narrative rhythms of *Knots Landing* than we might expect
it to do, as Mills also registers and respects the lived experi-
ence of time as social (a phenomenon discussed in chapter 1).
Turning her attention first to the social time spent outdoors "on
a tennis court or at a sporting event," she asserts that "there's
nothing worse" on these occasions than "seeing someone overly
made up—and that's exactly what will happen if you use electric

light" rather than natural light to guide application of makeup for these situations. These words introduce a segment titled with the seeming oxymoron, "Natural Make-Up." Mills's unintentionally ironic comment about appearing "overly made up" may strike us as less ironic when considered alongside her subsequent—and very self-aware—meditation on the difference between "look[ing] natural" and "being natural": "Being natural is not what I'm talking about here. It takes a little effort to look natural. It takes a little makeup." From the perspective of a different century's norms, we are probably disinclined to call the amount of makeup that Mills applies *little*. As a consequence, we probably can't countenance this cautionary remark with a straight face: "The only thing anyone wants to see is a pretty face, *not* what went into making it that way." Yet even so, Mills demonstrates a canny understanding of how to play paradox:

113

Donna Mills attends to her eyes in crucially natural light.

by artificing a "natural" look, for instance, or by revealing prettiness through concealment. And this talent helps to explain why an audience could have found her makeup starrily charismatic. In Roach's formulation, the "it" factor, or charisma, depends in its essence on the skillful mining of contraries, which are made not quite to contradict but rather to illumine each other (33–34). Such a mining of contraries is just what Mills aims to do with her eyes—and arguably achieves.

The achievement was real enough not just to help sell copies of *The Eyes Have It* instructional video but to launch a line of branded cosmetics, including the "Donna Mills 'The Eyes Have It' 15-pc. Makeup Kit" ("QVC: Product Detail") retailed successfully by QVC (Sullivan 2001). Mills's charismatic approach to making up may seem less frivolous in light of its harnessing to a serious business agenda. At the same time, the frivolity of the serious business (another example of interleaved contraries) is not only ours to comprehend. It was already apparent in the 1980s, as evinced by an oblique joke about *The Eyes Have It* in a 1988 installment of *Knots Landing*, "The Briar Patch" (episode seven in season ten). Business partners Abby, Gary, and Karen confront an exigent need to sell the resort Lotus Point, a venture made irretrievably infeasible because of damaging press. And cutting their losses means getting a flurry of unacceptable offers from "wackos." These dubious, would-be buyers include the proprietors of "Hair Dos and Don'ts, Incorporated," makers of a video featuring beauty tips. When Abby reads their proposal and describes their company to her partners, Karen says, "You're making this up." Yet Abby has in hand not only the "Hair" letter of interest but also the "Hair" videocassette to prove the company's realness. The subtle pun here on *making up* allows that phrase to mean *fabrication* and also to be heard as *cosmetic application*. Thus it cues us in to the fact that the ludicrousness of "Hair Dos and Don'ts" is a winking jibe at *The Eyes Have It* (a joke at which Mills is perfectly happy to laugh—all the way to the bank). Finally, the pun discloses something

more meaningful. It underscores the powerful inseparability of two *television* versions of "making up": storytelling in image and sound, and the putatively "trivial" aspects of audiovisual communication, like makeup.

Conclusion

"Will the Circle Be Unbroken?"

The song, "Will the Circle Be Unbroken?" provided *Knots Landing* with a borrowed title for one of its early memorable installments (episode five in season one). It also provided the content for a later duet between Julie Harris and Lisa Hartman in one of the "highly plural" scenes described in the last chapter. In turn, we may also ask about the circle and its integrity as we think about *Knots Landing* in a holistic way, with an eye to its legacy. The image of the circle is not incidental to such holistic thinking about *Knots Landing*. Indeed, the circle, in the form of the cul-de-sac that first brings together the series' cast of characters as neighbors and friends, is also the central image of the series itself. And this centrality is recognized reflexively in the final installment of *Knots Landing*. There, a winking series of plot contrivances return—circularly—long-departed denizens of Seaview Circle to their former residences on the cul-de-sac. The maneuver neatly maps the circle as a concept and as a spatial figure onto a likewise ring-shaped narrative. Much earlier, however, we encounter the appeal and binding power of the cul-de-sac *as* a cul-de-sac. Over the course of the series' run, the

street acquires thick meaning from its place in a fiscal economy, as part of a real estate market; it also has resonant meaning in a domestic economy, as the locus of home for its residents. First we see these two meanings intertwine in a series of fairly simple "housing plots," when Laura rejoins the labor force as a real estate agent and her success at work disturbs her already fragile marriage. Later, the cul-de-sac stands for "normality" as it contrasts with luxe environments. Those environments are glimpsed in a series of much more baroque multi-episode or season-long narrative arcs: plots that hinged on the series' increasing obsession, in the mid-1980s, for equally baroque real estate maneuvers.

Knots Landing is still "with us" when Alec Baldwin delivers a joke about Julie Harris in 30 Rock (NBC, 2006–13), or when Ted Shackelford and Joan Van Ark make guest appearances as Gary and Val in TNT's 2012 Dallas revival (TNT, 2012–14)—a final truce, as it were, after the earlier splintering of the earlier series. Yet the obsession with real estate also becomes a crucial, if less obvious, aspect of Knots Landing's legacy. We can start to understand the legacy by thinking of real estate's key role in the bourgeois crazes and appetites of the United States in the 1980s. Those crazes and appetites inform our own, however much the idea of "the '80s" (and its acquisitiveness) has been overtly disavowed after the recession of 2008 (Shimpach 516–17). Nonetheless, the '80s—and its television—paved the way for the strong, contemporary appeal of self-styled "lifestyle" television (Lykke Christensen 127). More specifically, the version of that reality television focused on renting, buying, selling, and renovating houses takes up something like Knots Landing's mantle. (Significantly, the 1994 launch of HGTV, a key player in the multichannel transition to the post-network era, comes directly on the heels of Knots Landing's termination.) Critics like Anna Everett see a sharp line between soap opera and the brand of house-oriented reality television "that, by contrast, is defined by a definite and dramatically transformed *end*" (158). I see, rather, a soft blur. Whatever

the relative weight of closure or open-endedness, constant *change* is central to both kinds of television. And in the cases of both *Knots Landing* and the reality TV, the depiction of that change is addressed to "home-owning, middle-class television viewers (and those aspiring to join that demographic)" precisely *as* caring homeowners or homeowner aspirants (Shimpach 518). Not for nothing does Laura's farewell video message to Karen, which positions the viewer much like Karen, include a request to find suitable tenants for her vacant house on Seaview Circle. They arrive in the form of Frank and Pat Williams: two characters in whose lives viewers may invest as an unfolding story reveals the Williamses to be members of the Witness Protection Program. Viewers may likewise invest in specific plot points within that story, like paranoid Frank's rending of his belatedly delivered sofa

Though Frank tears apart his sofa, viewers can appreciate a floral arrangement and carpeting choice.

when he thinks that criminals may have tampered with it. Yet the same viewers are just as likely to invest in the disposition of the house, period, and the precise nature of *all* the items with which it is furnished, not just the torn ones.

Thus we may trace a genealogy from today's reality programming back to its narrative progenitors like *Knots Landing*. Doing so constitutes my modest attempt to model, in miniature, the kind of television studies that I most admire. This version of television studies takes full account of unexpected but productive forms of meaning making. The meanings are capacious, imaginative, and robust; and their instigations move across series, across genres, and across periods. In the process of making them, we learn something, for instance, from *Knots Landing*'s emphases on middle-classness and home ownership. And what we learn may explain to us, here and now, aspects of ourselves and of our related television fascinations. At the same time, we may work in the opposite, chronological direction. One model for that work comes from cultural critic Theodor Adorno, writing in a very different context about Hegel's philosophy. (Given Adorno's careful and surprisingly fond attention to television in the 1950s, I think he would appreciate the translation.) Per Adorno: To ask the "question of what in [*Knots Landing*] has any meaning for the present," "because one has the dubious good fortune to live later," is to overlook a harder, "converse," and perhaps more important question: "what the present means in the face of [*Knots Landing*]" (1). In order to write this book, I re-watched a great deal of the series' episodes—and recalled, in great detail, earlier watching and re-watching of other episodes. At my most recreational (which is also to say, *re-creational*), I found myself gravitating to a portion of the series' tenth season. There, episodes focus on the aftermath of Jill's attempted murder of Val, which everyone initially mistakes, according to Jill's plan (if botched by Val's survival), for a suicide attempt. When the tide of belief turns slowly to Val, the other residents of the cul-de-sac help her prove Jill's crime. Their coming together in support of a member of their tribe shows us the strength of neighborly friendship,

a powerful and complex affective bond. Indeed, it is an *alternative kinship structure* that organizes lived, social time in rooted, social space. Such kinship fuels the felt experience that makes a house, Val's or Karen's, yours or mine, a home: a part of something bigger. In short, the private horror that happens inside the house is cathartically overcome in the public hearth of community. (Whether reality television focused on real estate and design has a similar capacity to show us these things remains to be tested as that genre evolves.) *Knots Landing* makes a poignant appeal to anyone who has experienced such private horror and the pain or, in its more extreme forms, trauma associated with that horror. This audience could do far worse than to learn something about their pain— along the way, laughing through tears or crying through giggles, or both—from *Knots Landing*'s vision of heartache and principle of hope.

121

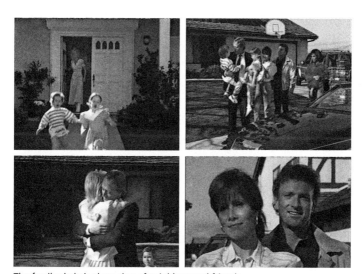

The family circle is also a ring of neighbors and friends.

1. Even earlier in its run, *Knots Landing* makes an implicit allusion to—and subtle dig at—*Dallas's* "dream work." When Val survives Jill's attack on her (a plot point discussed in detail in chapter 3), Gary keeps using the word *nightmare* to describe what he takes at first to be Val's hallucinated account of Jill's criminal behavior. Unlike *Dallas's* dreams, *Knots Landing's* nightmares are rooted in the real. And Gary and the other denizens of *Knots Landing* discover as much when Val's story is verified. Jacobs is right to highlight how much viewers may care about fidelity to such realness. It is a caring also measured humorously in the popular film *Hello Again* (1987), produced closely after the representation of Pam's dreaming in *Dallas*. The supernatural comedy features Lucy Chadman (Shelley Long)'s resurrection after a year of death (shades of Bobby!). Yet despite its occult premise drawing the film near to *Dallas*, its allegiance is finally to a realness more like *Knots Landing's*. This comes into focus when middle-class suburbanite Lucy says shortly after her revivification that, of all the events she has missed during her time in the grave, she wants to know most "what happened on *Knots Landing*."

2. Richard Dienst calls television's stitching together of the social and the temporal its "socialized culture time" (xi). Amy Villarejo names this phenomenon, more precisely, as television's "implantation of social time" (2012).

3. This note refers back to dialogue quoted in sentences that survey a number of *Knots Landing* episodes. The quotations come, respectively and in order, from "Remember the Good Times" (episode three in season two), "Night" (episode nineteen in season three), "Remember the Good Times," "Chance of a Lifetime" (episode four in season two), "Buying Time" (episode one in season six), "Moments of Truth" (episode fourteen in season two), "Moments of Truth," ". . . And Never Brought to Mind" (episode six in season five), "Night," "Acts of Love" (episode twenty in season three), "New Beginnings" (episode six in season four), and ". . . And Never Brought to Mind."

4. As an aside, I should note that both White's and Flitterman-Lewis's essays appear in the seminal anthology *Channels of Discourse, Reassembled*, the revised 1992 edition of a volume that made its first appearance in 1987. That volume contains two other essays whose fleeting references to *Knots Landing* are telling. (Perhaps, from a current perspective, they are even conspicuous.) Most revealing about these passing invocations of *Knots Landing* is their indication of how fully "in the air," and not just regularly on the air, the series was in the 1980s and early 1990s. Evidently a part of the casual or more sustained viewing routines of major television scholars, the series was one with which those scholars could expect their readerships to be likewise acquainted. Thus *Knots Landing* could furnish useful, telegraphic examples to illustrate points.

WORKS CITED

"1989 *Soap Opera Digest* Award Winners." 2003. *Soap Opera Digest and Soap Opera Weekly*. www.soapoperadigest.com/content/1989-0/.

"1990 *Soap Opera Digest* Award Winners." 2003. *Soap Opera Digest and Soap Opera Weekly*. www.soapoperadigest.com/content/1990-0/.

"Acts of Love." *Knots Landing*. Episode no. 51, first broadcast 22 April 1982 by CBS, running 60 min. Directed by Harvey Laidman and written by Jeff Cohn.

Adorno, Theodor. *Hegel: Three Studies*. Translated by Shierry Weber Nicholsen. Cambridge: MIT Press, 1993.

Alberoni, Francesco "The Powerless 'Elite': Theory and Sociological Research on the Phenomenon of Stars." In *Stardom and Celebrity: A Reader*, edited by Sean Redmond and Su Holmes, 65–77. Thousand Oaks, CA: SAGE Publications Inc., 2007.

". . . And Never Brought to Mind." *Knots Landing*. Episode no. 81, first broadcast 3 November 1983 by CBS, running 60 min. Directed by Larry Sheldon and written by Diana Gould.

Ang, Ien. *Watching Dallas: Soap Opera and the Melodramatic Imagination*. Translated by Della Couling. New York: Routledge, 1985.

Beckett, Samuel. *Waiting for Godot: A Tragicomedy in Two Acts*. New York: Grove Press, 1954.

Benson-Allott, Caitlin. "Made for Quality Television?" *Film Quarterly* 66, no. 4 (2013). www.filmquarterly.org/2013/12/made-for-quality-television/.

Bjorkman, Stig, Torsten Manns, and Jonas Sima. *Bergman on Bergman: Interviews with Ingmar Bergman*. Translated by Paul Britten Austin. New York: Simon & Schuster, 1973.

"Bottom of the Bottle: Part 1." *Knots Landing*. Episode no. 12, first broadcast 20 March 1980 by CBS, running 60 min. Directed by Roger Young and written by Calvin Clements, Jr.

Brown, Bill. "Thing Theory." *Critical Inquiry* 28, no. 1 (2001): 1–22.

Butler, Jeremy G. Introduction to "Stars as a Cinematic Phenomenon" by John Ellis. In *Star Texts: Image and Performance in Film and Television*, edited by Butler, 300–302. Detroit, MI: Wayne State University Press, 1991.

"Buying Time." *Knots Landing*. Episode no. 101, first broadcast 4 October 1984 by CBS, running 60 min. Directed by Alexander Singer and written by Kevin Alexander.

Caldwell, Sarah. "Is Quality Television Any Good? Generic Distinctions, Evaluations and the Troubling Matter of Critical Judgment." In *Quality TV: Contemporary American Television and Beyond*, edited by Janet McCabe and Kim Akass, 19–34. New York: I.B. Tauis & Co., 2007.

"Celebration." *Knots Landing*. Episode no. 71, first broadcast 10 February 1983 by CBS, running 60 min. Directed by Bill Duke and written by Mann Rubin.

"Chance of a Lifetime." *Knots Landing*. Episode 17, first broadcast 11 December 1980 by CBS, running 60 min. Directed by Nicholas Sgarro and written by John Pleshette.

"China Dolls." *Knots Landing*. Episode no. 52, first broadcast 10 April 1982 by CBS, running 60 min. Directed by Joseph B. Wallenstein and written by Wallenstein.

Collins, Jim. "Postmodernism and Television." In *Channels of Discourse, Reassembled: Television and Contemporary Criticism*, edited by Robert C. Allen, 327–53. Chapel Hill: University of North Carolina Press, 1992.

"Community Spirit." *Knots Landing*. Episode no. 2, first broadcast 3 January 1980 by CBS, running 60 min. Directed by James Sheldon and written by Elizabeth Pizer.

Creeber, Glen. "The Origins of Public Service Broadcasting." In *The Television History Book*, edited by Michele Hilmes, 22–26. London: BFI, 2003.

Cvetkovich, Ann. *Depression: A Public Feeling*. Durham, NC: Duke University Press, 2012.

Dienst, Richard. *Still Life in Real Time: Theory after Television*. Durham, NC: Duke University Press, 1994.

Dyer, Richard. *Stars*. Revised ed. London: BFI, 1998.

Edgerton, Gary R. *The Sopranos*. Detroit, MI: Wayne State University Press, 2013.

Ehrenreich, Barbara. *Fear of Falling: The Inner Life of the Middle Class*. New York: HarperCollins, 1990.

Ellis, John. *Visible Fictions: Cinema, Television, Video*. Revised ed. New York: Routledge, 1992.

Elsaesser, Thomas. "Quality Television: Introduction." In *Writing for the Medium: Television in Transition*, edited by Elsaesser, Jan Simons, and Lucette Bronk, 15–20. Amsterdam: Amsterdam University Press, 1994.

———. "Zapping One's Way into Quality: Arts Programmes on TV." In *Writing for the Medium: Television in Transition*, 54–63.

Esch, Deborah. *In the Event: Reading Journalism, Reading Theory*. Stanford, CA: Stanford University Press, 1999, 85–96.

Everett, Anna. "Trading Private and Public Spaces @ HGTV and TLC: On New Genre Formations in Transformation TV." *Journal of Visual Culture* 3, no. 2 (2004): 157–81.

The Eyes Have It. Directed by Ron Casden. Los Angeles, CA: MCA Video (Universal), 1986.

Fischer, Lucy and Marcia Landy. "The Network Television Star: Introduction." In *Stars: The Film Reader*, edited by Fischer and Landy, 229–30. New York: Routledge, 2004.

Feuer, Jane. *Seeing through the Eighties: Television and Reaganism*. Durham, NC: Duke University Press, 1995.

Feuer, Jane, Paul Kerr, and Tise Vahimagi, eds. *MTM: "Quality Television."* London: BFI, 1984.

Filerman, Michael. "Interview with Michael Filerman." By Jason Yates and James Holmes. 2006. *Knots Landing: Official TV Show Website*. www. knotslanding.net/interviews/michaelfilerman.html.

Flitterman-Lewis, Sandy. "Psychoanalysis, Film, and Television." In *Channels of Discourse, Reassembled*, 203–46.

Gainsborough, Juliet F. *Fenced Off: The Suburbanization of American Politics*. Washington, DC: Georgetown University Press, 2001.

Geraghty, Christine. "Aesthetics and Quality in Popular Television Drama." *International Journal of Cultural Studies* 6, no. 1 (2003): 25–45.

———. "Re-Appraising the Television Heroine." *CST Online*. September 6, 2013. http://cstonline.tv/re-appraising-the-television-heroine.

Gledhill, Christine. "Introduction." In *Stardom: Industry of Desire*, edited by Gledhill, xi–xix. New York: Routledge, 1991.

127

————. "Signs of Melodrama." In *Stardom: Industry of Desire*, 210–34.

Greenberg, Stanley B. *Middle Class Dreams: The Politics and Power of the New American Majority*. Revised and updated ed. New Haven, CT: Yale University Press, 1996.

Hachmeister, Lutz. "Television in the Age of Consensus without Sense." In *Writing for the Medium: Television in Transition*, 21–34.

Hartman, Lisa. *'Til My Heart Stops*. Wea Corp. January 1, 1987.

heartnouveau. "The Best of 'The Eyes Have It.'" *YouTube*. December 7, 2010. www.youtube.com/watch?v=v_xgxFEj9aw.

Hello Again. Directed by Frank Perry and written by Susan Isaacs. Burbank, CA: Touchstone Pictures, 1987. 96 min.

Hilderbrand, Lucas. *Inherent Vice: Bootleg Histories of Videotape and Copyright*. Durham, NC: Duke University Press, 2009.

Jacobs, David. "Interview with David Jacobs." By Colin Hunter. 2003. *Knots Landing: Official TV Show Website*. www.knotslanding.net/interviews/david.htm.

————. "Interview with David Jacobs." By Jason Yates and James Holmes. 2006. *Knots Landing: Official TV Show Website*. www.knotslanding.net/interviews/davidjacobs.htm.

————. "Introduction." *Knots Landing: The Saga of Seaview Circle*, by Laura Van Wormer, vii–viii. New York: Doubleday, 1986.

Jordan, Marion. "Realism and Convention." *Coronation Street*, edited by Richard Dyer, 27–39. London: BFI, 1981.

Kelly, Lisa W. "Television's Difficult Women." *CST Online*. October 31, 2013. http://cstonline.tv/televisions-difficult-women.

Keyser, Lester J. "*Scenes from a Marriage*: The Popular Audience." In *Ingmar Bergman: Essays in Criticism*. edited by Stuart M. Kaminsky with Joseph F. Hill, 313–23. New York: Oxford University Press, 1975.

King, Barry. "Articulating Stardom." In *Stardom: Industry of Desire*, 169–85.

Knight, Bob. "Review of *Knots Landing* pilot." *Variety*, January 2, 1980, 34.

"*Knots Landing* Reunion." *The Talk*. First broadcast 18 January 2013 by CBS.

Larson, Mark, and Barney Hoskins. *The Mullet: Hairstyle of the Gods*. London: Bloomsbury, 1999.

"The Last One Out." *Knots Landing*. Episode 300, first broadcast 25 April 1991 by CBS, running 60 min. Directed by Nicholas Sgarro and written by Bernard Lechowick.

Lathan, Lynn Marie, and Bernard Lechowick. "Interview with Lynn Marie Latham and Bernard Lechowick." By Arthur Swift. August 26, 2004.

Knots Landing Online. www.angelfire.com/tv2/Dukes/latham_and_lechowick_interview.html.

Leahy, Michael. "Tied up in *Knots*, She Only Wants to Sing." *TV Guide*, July 21, 1984, 12–15.

Lee, Michele. "Interview with Michele Lee." By Arthur Swift. 2003. *Knots Landing: Official TV Show Website*. www.knotslanding.net/interviews/michele.htm.

Lentz, Kirsten Marthe. "Quality versus Relevance: Feminism, Race, and the Politics of the Sign in 1970s Television." *Camera Obscura* 15, no. 1 (2000): 44–93.

"The Lie." *Knots Landing*. Episode no. 4, first broadcast 17 January 1980 by CBS, running 60 min. Directed by Edward Parone and written by Claudia Adams.

Littwin, Susan. "What Happened . . . When *Knots Landing* Turned Its Actors Loose without a Script." *TV Guide*, November 28, 1987, 8–12.

"The Longest Night." *Knots Landing*. Episode 160, first broadcast 15 May 1986 by CBS, running 60 min. Directed by Joseph Scanlan and written by David Paulsen.

Lotz, Amanda D. *The Television Will Be Revolutionized*. New York: NYU Press, 2007.

"Love and Death." *Knots Landing*. Episode 330, first broadcast 3 December 1992 by CBS, running 60 min. Directed by Menachem Bonetski and written by Lisa Seidman.

Lutz, Tom. *Crying: The Natural & Cultural History of Tears*. New York: Norton, 1999.

Lykke Christensen, Christa. "Lifestyle as Factual Entertainment." In *Relocating Television: Television in the Digital Context*, edited by Jostein Gripsrud, 125–38. New York: Routledge, 2010.

Lyons, Margaret. "It Was a Good Year for Women on TV." *Vulture,* December 17, 2013. www.vulture.com/2013/12/women-on-tv-orange-is-new-black.html.

McElroy, Ruth. "Property TV: The (Re)Making of Home on National Screens." *European Journal of Cultural Studies* 11, no. 1 (2008): 43–61.

McMillin, Scott. *The Musical as Drama*. Princeton, NJ: Princeton University Press, 2006.

"Middle-Class Blues." *National Review*, November 7, 1994, 14–15.

"Moments of Truth." *Knots Landing*. Episode 27, first broadcast 26 February 1981 on CBS, running 60 min. Directed by Jeff Bleckner and written by Robert Gilmer.

129

Moseley, Rachel. "'Real Lads Do Cook. . . . But Some Things Are Still Hard to Talk About': The Gendering of 8–9." *European Journal of Cultural Studies* 4, no. 1 (2001): 32–39.

Most, Andrea. "Opening the Windshield: *Death of a Salesman* and Theatrical Liberalism." *Modern Drama* 50, no. 4 (2007): 545–64.

"Museum of Television and Radio's 12th Annual Television Festival in Los Angeles: *Knots Landing*." Panel discussion moderated by Robert M. Batscha. March 17, 1995. Recording archived by The Paley Center for Media.

Nancy, Jean-Luc. "The Two Secrets of the Fetish." Translated by Thomas C. Platt. *Diacritics* 31, no. 2 (2001): 2–8.

"New Beginnings." *Knots Landing*. Episode 59, first broadcast 29 October 1982 by CBS, running 60 min. Directed by Lorraine Senna Ferrara and written by Mann Rubin.

Newcomb, Horace. "*Magnum*, Champagne of Television?" *Channels of Communications* May/June (1985): 23–26.

Newman, Michael, and Elana Levine. *Legitimating Television: Media Convergence and Cultural Status*. New York: Routledge, 2011.

"Night." *Knots Landing*. Episode 50, first broadcast 15 April 1982 by CBS, running 60 min. Directed by Alexander Singer and written by John Pleshette.

"No Miracle Worker." *Knots Landing*. Episode 177, first broadcast 8 January 1987 by CBS, running 60 min. Directed by Kate Swofford Tilley and written by Bernard Lechowick.

"Noises Everywhere: Part 1." *Knots Landing*. Episode 200, first broadcast 3 December 1987 by CBS, running 60 min. Directed by David Jacobs and written by Bernard Lechowick.

"Noises Everywhere: Part 2." *Knots Landing*. Episode 201, first broadcast 10 December 1987 by CBS, running 60 min. Directed by David Jacobs and written by Lynn Marie Latham.

Nowell-Smith, Geoffrey. "'Quality' Television." In *Writing for the Medium: Television in Transition*, 35–40.

"Only 'Til Friday." *Knots Landing*. Episode 203, first broadcast 7 January 1988 by CBS, running 60 min. Directed by Lawrence Kasha and written James Stanley.

Paskin, Willa. "Network TV Is Broken. So How Does Shonda Rhimes Keep Making Hits?" *The New York Times*, May 9, 2013. www.nytimes.com/2013/05/12/magazine/shonda-rhimes.html?pagewanted=all&_r=0.

Patterson, Robert W. "Failure to Appeal to Middle Class Doomed GOP Ticket." *Philly.Com*, November 12, 2012. http://articles.philly.com/2012–11-12/news/35050795_1_middle-class-mitt-romney-election-day.

"The Perfect Crime." *Knots Landing*. Episode 219, first broadcast 12 May 1988 by CBS, running 60 min. Directed by Joseph Scanlan and written by Bernard Lechowick.

Peyser, Marc, with Devin Gordon and Julie Scelfo. "Six Feet under Our Skin." *Newsweek*, March 18, 2002, 52.

"Pilot." *Knots Landing*. Episode 1, first broadcast 27 December 1979 by CBS, running 60 min. Directed by Peter Levin and written by David Jacobs.

Pleshette, John. "Interview with John Pleshette." By Arthur Swift. 2003. *Knots Landing: Official TV Show Website*. www.knotslanding.net/interviews/john.htm.

Polan, Dana. *The Sopranos*. Durham, NC: Duke University Press, 2009.

Powell, Margaret K., and Joseph Roach. "Big Hair." *Eighteenth-Century Studies* 38, no. 1 (2004): 79–99.

Press, Eyal. "Straight down the Middle." *The Nation*, November 8, 2004, 18–20.

"Primetime Soaps." *Pioneers of Television*. Episode 10, first broadcast 22 January 2013 by PBS, running 55 min.

"QVC: Product Detail: Donna Mills 'The Eyes Have It' 15-pc. Makeup Kit." *QVC*. www.qvc.com/.product.A38789.html.

"Remember the Good Times." *Knots Landing*. Episode 16, first broadcast 4 December 1980 by CBS, running 60 min. Directed by James Sheldon and written by Diana Gould.

"Return to Camelot: Part 1." *Dallas*. Episode 223, first broadcast 26 September 1986 by CBS, running 60 min. Directed by Leonard Katzman and written by Leonard Katzman and Mitchell Wayne Katzman.

Roach, Joseph. *It*. Ann Arbor: University of Michigan Press, 2007.

Rubinstein, Ed. "The Richest Americans." *National Review*, April 18, 1994, 16.

Ryan, Maureen. "Gillian Anderson, 'The Fall,' and the Rise of Subversive Genre Fare." *The Huffington Post*, June 13, 2013, www.huffingtonpost.com/maureen-ryan/gillian-anderson-the-fall_b_3437487.html.

Salvato, Nick. "On the Bubble: The Soap Opera Diva's Ambivalent Orbit." *Camera Obscura* 22, no. 2 (2007): 102–23.

Seiter, Ellen. "Semiotics, Structuralism, and Television." In *Channels of Discourse, Reassembled*, 31–66.

Sepinwall, Alan. *The Revolution Was Televised: The Cops, Crooks, Slingers and Slayers Who Changed TV Drama Forever.* Self-published, 2012.

Sherrow, Victoria, ed. *Encyclopedia of Hair: A Cultural History.* Westport, CT: Greenwood, 1996.

Shimpach, Shawn. "Realty Reality: HGTV and the Subprime Crisis." *American Quarterly* 64, no. 3 (2012): 515–42.

Simon, Ron, Robert J. Thompson, Louise Spence et al. *Worlds without End: The Art and History of Soap Opera.* New York: H. N. Abrams, 1997.

Singer, Ben. *Melodrama and Modernity: Early Sensational Cinema and Its Contexts.* New York: Columbia University Press, 2001.

Stacey, Jackie. "Feminine Fascinations: Forms of Identification in Star-Audience Relations." In *Stardom: Industry of Desire,* 145–68.

Sosnaud, Benjamin, David Brady, and Steven M. Frenk. "Class in Name Only: Subjective Class Identity, Objective Class Position, and Vote Choice in American Presidential Elections." *Social Problems* 60, no. 1 (2013): 81–99.

Spigel, Lynn. *Make Room for TV: Television and the Family Ideal in Postwar America.* Chicago: University of Chicago Press, 1992.

Sullivan, Paul. "Where Are They Now? Donna Mills's Makeup Has Successful Landing on QVC." *The Boston Herald,* November 6, 2001. http://business.highbeam.com/3972/article-1G1–79795713/they-now-donna-mills-makeup-has-successful-landing.

Thompson, Robert J. *Television's Second Golden Age.* Syracuse, NY: Syracuse University Press, 1997.

"The Unraveling." *Knots Landing.* Episode 176, first broadcast 1 January 1987 by CBS, running 60 min. Directed by Nicholas Sgarro and written by Lou Messina and Dianne Messina.

"Until Parted by Death." *Knots Landing.* Episode 139, first broadcast 21 November 1985 by CBS, running 60 min. Directed by Larry Elikann and written by Bernard Lechowick.

Van Ark, Joan. "Interview with Joan Van Ark." By Arthur Swift. 2003. *Knots Landing: Official TV Show Website.* www.knotslanding.net/interviews/joan2.htm.

Villarejo, Amy. "On Television: Duration, Endurance, Ethereality." Public lecture at Hollis E. Cornell Auditorium, Cornell University, Ithaca, NY, July 9, 2012.

Webb, Teena. "*Scenes from a Marriage*: Bergman without Options." *Jump Cut: A Review of Contemporary Media* 1, no. 5 (1975): 1–2.

White, Mimi. "Ideological Analysis and Television." In *Channels of Discourse, Reassembled*, 161–202.

———. White, Mimi. "Women, Memory and Serial Melodrama." *Screen* 35, no. 4 (1994): 336–53.

Wilker, Deborah. "Back in the Sac at *Knots Landing*." *Sun-Sentinel*, May 1, 1997.

"Will the Circle Be Unbroken?" *Knots Landing*. Episode 5, first broadcast 25 January 1980 by CBS, running 60 min. Directed by David Moessinger and written by David Jacobs.

Williams, Linda. *Playing the Race Card: Melodramas of Black and White from Uncle Tom to O. J. Simpson*. Princeton, NJ: Princeton University Press, 2002.

Zimmerman, Patricia Rodden. *Reel Families: A Social History of Amateur Film*. Bloomington: Indiana University Press, 1995.

Zynda, Thomas H. "The Metaphoric Vision of *Hill Street Blues*." *Journal of Popular Film & Television* 14, no. 3 (1986): 100–113.